Amos

An Invitation to the Good Life

JENNIFER ROTHSCHILD

Lifeway Press®
Nashville, Tennessee

Published by Lifeway Press® • © 2022 Jennifer Rothschild

ISBN: 978-1-0877-6427-6 • Item: 005837660
Dewey decimal classification: 244.8
Subject headings: BIBLE. O.T. AMOS—STUDY AND TEACHING / CHRISTIAN LIFE / AMOS, PROPHET

To order additional copies of this resource, write to Lifeway Resources Customer Service; 200 Powell Place, Suite 100, Brentwood, TN, 37027-7514; order online at lifeway.com; fax 615.251.5933; phone toll free 800.458.2772; or email orderentry@lifeway.com.

Printed in the United States of America

Lifeway Women Bible Studies
Lifeway Resources
200 Powell Place, Suite 100,
Brentwood, TN, 37027-7514

Cover design by Lauren Ervin

EDITORIAL TEAM, LIFEWAY WOMEN BIBLE STUDIES

Becky Loyd
Director, Lifeway Women

Tina Boesch
Manager

Chelsea Waack
Production Leader

Mike Wakefield
Content Editor

Erin Franklin
Production Editor

Lauren Ervin
Art Director

Sarah Hobbs
Graphic Designer

TABLE OF CONTENTS

ABOUT THE AUTHOR

Amos: An Invitation to the Good Life is Jennifer's eighth video-based Bible study with Lifeway. It follows her popular Bible studies, *Take Courage: A Study of Haggai*; *Psalm 23: The Shepherd with Me*; *Hosea: Unfailing Love Changes Everything*; and *Me, Myself, and Lies: A Thought-Closet Makeover*.

Jennifer has shared her inspiring messages to audiences across the country and through media outlets including *Dr. Phil*, *Good Morning America*, the *Today Show*, and the *Billy Graham Television Special*. She's the featured teacher and founder of Fresh Grounded Faith Women's Events and hosts the *4:13 Podcast* where she offers practical encouragement and biblical wisdom to help women live the "I can" life. Jennifer is also the publisher of the popular online leadership library called womensministry.net.

Jennifer is known for her substance, signature wit, and down-to-earth style. A unique mix of profound and playful, she weaves biblical truth with relatable stories, making God's Word accessible to those just starting out in Scripture and endearing to those who have walked with Christ for years.

She's a C. S. Lewis junkie, an obsessive audiobook listener, a dark chocolate lover, and she drinks way too much strong coffee.

She's been blind since age fifteen and says the greatest lesson she's learned in the dark is that it doesn't have to be well with your circumstances to be well with your soul. Jennifer is a boy mom who lives in Missouri with her husband, whom she affectionately calls her very own Dr. Phil, and their little diva dog, Lucy!

Connect with Jennifer at jenniferrothschild.com/amos.

HOW TO USE THIS STUDY

GROUP GUIDE: In addition to the Leader Helps in the back of this book, I've provided a simple group plan. Each session begins with a two-page group guide. I suggest you divide your group time into three parts: 1. Welcome and prayer; 2. Watch the video; 3. Group discussion of the personal study for the past session and the video you just watched.

PERSONAL STUDY: Each invitation, you'll have five days of personal study. (It will be fun—I promise!) Plan to spend a few minutes completing each day's study. Don't worry if some days you don't get it all done. This isn't a race, and you can come back later. Day Five of each invitation is a personal reflection day.

GROUP RESOURCES: If you're leading the group, you'll find an additional word to leaders on page 197.

If you're doing this study on your own, I encourage you to invite a friend or two to join you. This will give you study buddies to pray with and connect with over coffee or through text or email so you can chat about what you're learning.

TO ACCESS THE VIDEO TEACHING SESSIONS, USE THE
INSTRUCTIONS IN THE BACK OF YOUR BIBLE STUDY BOOK.

5

WHY YOU WANT TO READ AMOS

My charming little niece pretzeled her long skinny legs into a brown plastic chair in her grandpa's hospital room. I sat near her on the edge of his bed. We were keeping vigil over this man we both loved. She was trying to read her assigned seventh grade English book, and her Aunt Jennifer was constantly interrupting her.

"What's your favorite subject?"

"Do you like to read?"

"What's the book about?"

She finally rested her book on the lap of her tattered jeans and gave in to my questions.

"It's about a horse."

Evidently, her Aunt Jennifer has a thing about stress chatter. Do you know what that is? It's that thing in me that will engage my mouth as much as possible so my heart doesn't have to feel and my brain will stop doing the "what if" calculations. We were in the hard middle of losing our hero dad/grandpa, and the process was terribly painful and full of stress. So evidently, I was overcompensating by chattering on and on in his hospital room that day.

"I don't like to read books about animals because they usually get hurt or lost or die, and I just can't handle it," I said.

Juliet loves animals, and I figured she may feel the same way about reading the horse book, so I continued.

"I don't like reading books full of bad news or sad outcomes. How about you?"

From that brilliant little brain of hers, hidden beneath sunshiny blond hair, she said, "Well, Aunt Jennifer, I'm not afraid to read it because the horse is the narrator."

Now, any woman who has been through menopause knows that more pauses come with it! There is a reason some call it "mental pause." It can sure stop stress chatter, though!

I just sat there on the end of the bed pondering her conclusion.

Evidently, my pause made her think she needed to clarify what she meant. She figured out that Aunt Jennifer was a little slow to connect the dots!

"If the horse is the narrator," she explained, "then the book will end OK."

Juliet's point was well taken. The horse didn't die if he was the one telling the story. (It's OK if you're saying "duh" about now! Maybe that should have been more obvious to me!)

But the bigger point was that Juliet didn't need to hesitate. She didn't need to quit reading to protect her heart. She didn't need to fear discouragement as she went through each chapter because no matter how bad it got, no matter how bleak or sad or awful the chapter, she knew the story would end well.

Years later I sit at my desk listening to my computer read the book of Amos to me. (By the way, if we're new friends, this is a good time to let you know I'm blind. That's why my computer reads to me.)

With every chapter, it's just bad news after bad news. Every chapter makes me feel discouraged or want to quit reading. At the very least, I wonder, *And why am I thinking a woman would want to do a Bible study on Amos with all its bad news?*

Then I remember Juliet's sage words in the hospital that day: "I'm not afraid to read it because the horse is the narrator. If the horse is the narrator, then the book will end OK."

So I keep reading Amos and thinking, *If hope is the narrator, then the book will end OK.*

And that is why you want to read Amos, too. Hope is the narrator of Amos.

Even though there are harsh words, bleak outcomes, scary condemnations, and all-around bad news, hope is still hidden in every word. Hope carries the narrative, and hope wins in the end.

So as we read Amos together, we're going to turn each condemnation into an invitation. Amos is full of invitations to seek God and live. It's full of invitations to feel assured by God, live humbly and justly for Him, and receive hope of renewal and restoration. So don't let the bad news or sad outcomes keep you from reading. "If hope is the narrator, then the book will end OK."

And it will, sister! I promise. Besides that, along the way your heart may just explode with the possibilities, joy, and assurance old Amos will bring. Open your heart big to receive these seven invitations from the heart of God through the pen of Amos. They are for you. And once accepted, they will flow through you. You're about to learn that what you long for—the good life—is wrapped up in living the God life and, girl, what a life it is!

So ready, set, receive!

Love,

Jennifer

INTRODUCTION:

The Good Life Is the God Life

To access the video teaching sessions, use the instructions in the back of your Bible study book.

BEFORE THE VIDEO
Welcome and Prayer

VIDEO NOTES

The good life disappears unless we know how to _____ it correctly.

The Israelites weren't really living the good life because they had rejected

the _____ life.

FOUR THEMES IN AMOS:

1. Privilege brings _____.

2. Past history is not a substitute for present _____.

3. Religious ritual is not the same as true _____.

4. God is _____ in judgment and restoration.

If you want to review what you just experienced, go to jenniferrothschild.com/amos to get a written summary of this video message.

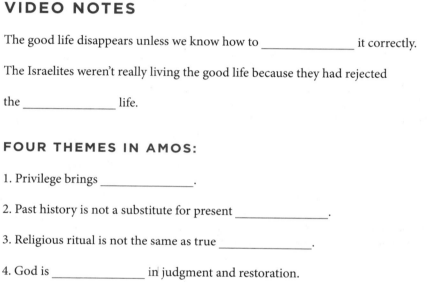

CONVERSATION GUIDE

▶ Why did you choose to do this study of Amos?

▶ How do you think most people in our culture would define the good life? How would you define it?

▶ This study will repeatedly state that the God life is the true good life. But why are we sometimes tempted to not believe that truth?

▶ Amos was just a common guy called to a God-sized task. How has that also been your story? In what ways is that the story for all of us who follow Christ?

▶ Which of the four themes prevalent in the book of Amos intrigues you the most and why?

▶ What do you hope to get out of this study of Amos?

INVITATION ONE

YOU ARE INVITED TO

Live Assured

Day One

NOT SO FAMOUS AMOS

. . . any one who reads him with due attention will find him, though a herdsman, not a whit behind the very chiefest prophets; almost equal to the greatest in the loftiness of his sentiments; and not inferior to any in the splendor of his diction, and the elegance of his composition. And it, is well observed, that the same heavenly Spirit which inspired Isaiah and Daniel in the palace, inspired David and Amos in their shepherds' tents.[1]

Bishop Robert Lowth

Hey, my friend! Pull up a chair and let's talk Amos! I've poured my coffee, but I will admit first thing that I would much rather sit here with this hot dark coffee and munch my way through a bag of, you guessed it, Famous Amos® chocolate chip cookies. Ever had one—or one hundred? (Because you just can't stop at one cookie.)

Oh. My. Goodness.

I do have a fondness for the famous cookie maker because he was born in Tallahassee, Florida, where I lived for many years. He baked the tastiest little cookies and tucked them into the perfectly sized bags. Each bag of bite-sized delights used to have a picture of a smiling Famous Amos spinning a chocolate chip cookie on the tip of his finger like a Globetrotter® with a basketball.

All I can say is every time I think of Amos, I can't get Famous Amos and his cookies off my mind!

So we need to get to know this Amos—Not So Famous Amos—with whom we'll be spending lots of time.

Let's ask God to guide us as we get started. *Lord, open our hearts as we open Your Word. Amen.*

ALL RIGHT, LET'S GO! OPEN YOUR BIBLE TO AMOS 1:1. A ton of information is packed in this one little verse. Read it and use the following questions to dig out all the juicy info on old Amos.

Who was Amos?

Where was Amos from?

What does his prophecy contain?

When did Amos prophesy?

In Amos 1:1, the ancient Hebrew literally means "sheep raiser."[3] Perhaps Amos used that title instead of "shepherd" to communicate that he really was a shepherd but was emphasizing with humility and clarity that he wasn't a shepherd in the spiritual sense.

Yep, those are the facts all in one verse! Amos was a shepherd and fig grower (you'll discover this later) who lived in Tekoa in Judah. He left home as a prophet to speak God's message to the Northern Kingdom of Israel. This was when Jeroboam II was on the throne of Israel, between 786–746 BC.[2]

Did you notice that in your answers about Amos, you didn't write "prophet" anywhere? You wrote "sheep herder" (or "shepherd" or "sheep breeder").

So what gives? Was he a shepherd or a prophet?

Well, for the most part, the people we know as prophets in the Bible didn't get a paycheck from the gig. It wasn't their profession. While they were doing their thing, like taking care of sheep, God called them out to speak for Him. And they weren't all cut from the same cloth either. Jeremiah and Ezekiel were priests when God raised them up as prophets. Like Amos, Moses was minding his own business tending sheep. And then there were the ladies! Deborah was a judge, and Huldah was likely a teacher.

What about you? What do you do? I'm a _____.
Or, I _____.

How would you feel if God plucked you from your thing and said, "Go here and do this and say that for Me"? Scared? Excited? Hesitant? Under-qualified? Willing? All of the above?

Did you wonder about the earthquake in Amos 1:1? "Geologists have measured disruptions in the layers of sediment in the Dead Sea that lay along a major fault line that indicate when major quakes occurred in the region."[4] They found the largest earthquake of the last several thousand years likely occurred around 760 BC, coinciding with the Amos account. This biblical quake was also mentioned by the prophet Zechariah (Zech. 14:5) and the Jewish historian Josephus.[5]

Me? All. Of. The. Above! I want us to pause together and really think about this because Amos was as ordinary as you and me. He was far more familiar with sheep husbandry than Torah scholarship. He didn't dress the part or have a prophet pedigree. I wonder if he was hesitant. I wonder if he plucked a ripe fig from one of those trees and thought, *Am I even qualified to do anything besides pick these things?*

We don't often feel qualified to do what God calls us to do. We're fearful or hesitant. But, sister girl, obedience isn't fueled by feelings. Obedience is fueled by faith.

THE GOD LIFE IS A LIFE OF FAITH.

What did Amos say about himself and his qualifications in Amos 7:14-15?

How did Amos stating that he wasn't a prophet or a prophet's son (v. 14) inform your understanding of the importance of family history when it comes to following God's call?

To me, that says your family history does not dictate the if, how, or when you will step into "His" story. It says that no matter where your family tree is planted, you can still blossom! No matter how bent and broken the branches on your family tree may be, God can still pluck you out and plant you anywhere He chooses. Girl, you do not need to be raised in the church to have a ministry in and to the church. You do not need to have a perfect history to help change history through your obedient, yielded life. Amos didn't come from prophet pedigree, but that didn't mean he couldn't be a prophet.

Our present, our past, our problems, our personalities—none of those predict or preclude us from being and doing what God sets before us. We need to be willing, like Amos, to be who God is calling us to be and do what He is calling us to do.

Amos 7:15 explains that God took Amos "from" and sent him "to." Let's pray for the spirit of Amos. As you open your hands and heart to God in prayer, deeply consider where you are, what you do, and your willingness to be open to following God's call as Amos did—even though it may look very different from his.

Dear God,

Amen.

I'm praying along with you. I want to have the courage Amos had to be who God calls me to be and do what He calls me to do—even if it feels out of my depth. Amos was a simple man, doing his thing, and God called him to minister. Answering that kind of call isn't always easy, of course.

In fact, use your favorite Bible resource (or you can even use Google®) to find out what Amos's name actually means.

Amos means: _____.

You'll learn over the next few weeks that most of Amos's prophecies were all about impending judgment on either Israel's neighbors or Judah and Israel themselves. Pretty heavy stuff. Amos was a man who carried a heavy burden. So no wonder his name means "burden" or "burden bearer."[6] But he didn't avoid the hard. He didn't run from the heavy. I don't want us to either, my friend. Amos ran toward what God called him to, even though it meant leaving home.

LOOK AGAIN AT AMOS 1:1. Remember where Amos lived? Amos was from Tekoa, a city about ten miles from Jerusalem.

Where does Amos 7:13 tell us Amos did most of his unpopular preaching?

Bethel was one of the southernmost cities of Israel—not very far from Tekoa. (Check out the map on p. 199 to locate this city.) But the people of Bethel were a million miles away from where God called them to be spiritually.

At the time Amos put on his prophet hat, God's people had been divided into two nations for more than 150 years. Judah, Amos's home, was the Southern Kingdom; Israel was the Northern Kingdom. Israel had only bad kings while Judah had a few good ones in her line of leaders. Amos 1:1 mentions two of them.

> **Look again at Amos 1:1 and write the names of the two kings mentioned:**
> _____ and _____.

Uzziah was Judah's king at the time, but the other king mentioned is who I want us to get to know. Jeroboam II was king over the place you, Amos, and I will be spending the majority of our time.

> **Summarize the reign of Jeroboam II based on what you read in 2 Kings 14:23-29.**

Jeroboam, the son of Jehoash, was one of the better kings among the bad kings that came before him—especially in a political and military sense. But that wasn't saying much. He was still ungodly, doing "evil in the LORD's sight" (v. 24, CSB). The blessing and curse of his reign was that Israel was prosperous but spiritually bankrupt and morally corrupt.

Let's finish up by noting an important fact about Bethel that helps us understand the challenge of Amos's ministry.

> **LOOK AGAIN AT AMOS 7:13. Jot down how Bethel is described.**

Bethel was called "the king's sanctuary and the national place of worship!" (NLT). Ahh, cue Handel's *Messiah*! Sounds like Westminster Abbey or Notre Dame, a place where the nation collectively honors God with reverence. Not so much.

> **READ 1 KINGS 12:25-30 to get a clear view of the history of the temple in Bethel.**

Imagine you are visiting the temple in Bethel at this time. Based on those verses, write a postcard to send home to your BFF or spouse about what's taking place there.

I bet you described some shiny idols. Sad, isn't it? Centuries before Amos, King Jeroboam I set up calf idols in Bethel. Really? Do we never learn? Anyway, by the time King Jeroboam II was on the throne and Amos was on the scene, the worship of God had descended into idolatry and empty ritualism. So Amos set up shop right there at that temple in the glow of the golden calf. He bore the burden of speaking truth to God's people who spiritually and morally were a wreck.

I imagine Not So Famous Amos standing by that temple, clad in a sheepskin tunic with a pocketful of dried figs, speaking God's words to God's people. But the ancient words of Amos are not just for an ancient audience. They are for now and for us. The themes of his messages echo in the New Testament words of the apostles and our Messiah.

Now that Not So Famous Amos is a little more familiar, let's finish up by getting a taste of Amos's message. I bet it will be more satisfying than those chocolate chip cookies!

Did you know Amos and Hosea prophesied at the same time? Amos lived in Judah but prophesied in Israel. Hosea lived in Israel and prophesied to his own people. The content of their messages was similar and the historical context was identical, but they communicated God's message very differently. Hosea portrayed Israel as an unfaithful spouse. Amos portrayed Israel as an unjust hypocrite. Yet both portrayed God as just, faithful, and merciful.

Read each passage in Amos and jot down what it reveals or admonishes. Then read the corresponding passage listed from the New Testament and think about how it relates to Amos's message. Choose one or two of the Scriptures to use as your finish-up prayer. (Or if you are more ambitious or have more time, instead of doing this activity, read through Amos and ask the Holy Spirit to show you passages that remind you of New Testament verses and jot them in the margin or a journal.)

	REVEALS OR ADMONISHES	NEW TESTAMENT PASSAGES
AMOS 2:4		Romans 15:4
AMOS 3:1-2		Hebrews 12:6
AMOS 4:13		Romans 1:20
AMOS 5:4		Matthew 6:33
AMOS 6:8		1 Peter 5:6
AMOS 9:13		Ephesians 3:20

Friend, my prayer for you and me is that we seek God and live (Amos 5:4; Matt. 6:33). I pray that God will draw us to His Word, His kindness, and His hope and that we will seek Him and experience the abundance that comes from living the God life because that's the good life!

Lord, make us like Your servant Amos. May we be willing to go, say, do, and live according to Your will. We open our hearts to receive Your invitation to seek You and live. Amen.

Well, we're off to a good start! The Lord guided us as we studied His Word, and we give Him praise. *Thank You, Lord, for Your Word. Amen.*

Now, go eat a Famous Amos chocolate chip cookie and call it a day!

Day Two

HERE COMES THE JUDGE

Sin is too dull to see beyond himself.[7]

Alfred Lord Tennyson

Oh, my friend, things are heating up fast in Amos! I've got my coffee, and I'm ready.

For the rest of this week, we're going to look at Amos 1 and the first part of chapter 2 to examine how God, through Amos, pronounced judgment on six of Israel's enemy nations. The Israelites' sins caught up with them big time. Today we will look at God's judgment of three of them and discover how His condemnation is an invitation for us to live assured that God sees and cares about us, His children.

PAUSE AND ASK GOD'S HOLY SPIRIT TO GUIDE YOU. THEN READ AMOS 1:2-10. But brace yourself, it won't be pretty! And don't get overwhelmed by confusing syntax. I'll explain after you read.

OK, wow, right? You may want to top off your coffee or brew some tea now because what we're about to do will require you to use the most brainpower in our study today. But, sister, you've got this! We're going to make this passage easier to understand by filling out a chart.

First, write the name of the nation in the first column next to the corresponding verses. Then, in the second column, jot down the sin(s) Amos called out. Lastly, in the third column, write down the judgment—consequences for the sin. (Just make notes. No need to be verbatim or interpret the details. Sip your coffee and keep it simple, sister!)

	NATION	SINS	JUDGMENT
AMOS 1:3-5			
AMOS 1:6-8			
AMOS 1:9-10			

We'll unpack and apply the chart in a minute.

But first, did you notice how each judgment began? What opening statement did all the judgments have in common?

Amos used this phrase (or a similar phrase) eight times in his prophecy. It was his special way of communicating sin and judgment.

Look back at what you wrote in the second column of your chart. You probably found that "for three sins . . . even for four" is not followed by four specific sins (NIV). In fact, Amos's typical style was to just mention one or two sins.

If he wasn't listing three or four sins per nation, why do you think he used that phrase? What could it mean?

The "for three . . . even for four" phrase was Amos's way of communicating excess. "Three sins" represents fullness or completeness; "four" represents the tipping point for God.[8]

Calling out "even for four" is like saying you're overflowing—you've outdone yourself— and this thing is out of control! The word for *sins* (*crimes* in the CSB translation and *transgressions* in the ESV translation) used in Amos can also be translated as "rebellion."[9] Each condemned nation was in rebellion against God's standard, not just against Judah or Israel.[10] And the way Amos introduced these condemnations with the "for three . . . even for four" phrase just shows how self-defeating and self-sabotaging sin can be. Their rebellion was not going to end well.

So far, not so good.

Now to the judgment column. Go back and review that bleak list. When you read the way God responded, does it seem He took their sins seriously?

Well, yes, He did! So why does it matter to you that some ancient rogue nation misbehaved and paid the price for it? It matters right now in your real life because of who these nations were, who they were messing with, and what it says about God and you.

If you want to look up each city or nation in your favorite Bible resource, do it, sister! Take some notes about who they were and what they did. Or if the chart already wore you out, just sit back, sip your coffee, and let me do it for you!

DAMASCUS

Damascus is the capital of Syria. Damascus viciously attacked Gilead which belonged to Israel. The mention of "*threshing sledges* with iron prongs or teeth [is] probably a figure of speech implying extreme cruelty and utter thoroughness in the treatment of those who opposed the Damascan invasion."[11]

GAZA AND TYRE

Gaza was a city-state in Philistia, along with Ekron, Ashdod, and Ashkelon. Gaza kidnapped a whole community of innocent people and sold them into slavery to Edom. "Gaza did not even need the slaves. She merely sold them to Edom for more money."[12]

And then there's Tyre, the strongest of the Phoenician cities.[13] Tyre did exactly what the Philistines did by selling God's people to Edom. (Look for Tyre and Edom on the map on p. 199 of your Bible study book.)

> **What does God's response to Gaza and Tyre tell you about what God cares about?**

Sometimes, like the ancients, we are mistreated, taken advantage of by others, and left feeling powerless. This happens to whole communities like the persecuted church, and individuals, like you. God takes seriously those who mistreat and hold you captive by their selfishness, cruelty, or greed. You can live assured that God sees and cares when His children are mistreated. Opposition and enemies may surround you, but you are in the center of God's care.

What element did God promise to use in meting out His punishment to each of these nations?

READ ZECHARIAH 2:4-5. I want you to see something so reassuring. How did God describe whom He would be to Jerusalem?

In context, God promised His people there would come a day when Jerusalem would be a city without walls because there would be so many people and animals inhabiting it. But on that day, the city wouldn't need walls because God would be their protection, their wall of fire.[14]

The principle of this promise applies to you and me today. This may make more sense as a visual. Funny, right? The blind woman is giving you a visual. Well, go with me. If you look at the map on page 199, you'll see the three places mentioned in our study today, plus the three nations Amos is about to call out, surround Israel. They literally form a circle around God's people. Now, imagine judgment falling all at once on those nations. What would you see? A ring of fire. If Michael W. Smith were there with Amos, we'd hear him singing, "It may look like I'm surrounded, but I'm surrounded by You"![15] God will be like a wall of fire around you. He is the One who will avenge and pronounce judgment on the enemies that surround you with hate or abuse. He will be the glory in your midst. His presence is forever with you.

(Pause for clarification here. This does not mean a woman should remain in an abusive relationship simply because God's presence surrounds her. If that's you, experience God's protection through confiding in a trusted friend and getting safe.)

Sometimes, like ancient Israel, we have been wronged. Meanies barge in and destroy our sense of security. They topple our sense of stability. They overwhelm, overtake, and overrun us. God takes it seriously. He wants you to know you are surrounded by His wall of fire. He is the glory in your midst.

You can live assured that no matter what the situation looks like to you, God sees and cares about you just like He did ancient Israel. And may I remind you: Israel wasn't on her best behavior at the time these prophecies were written, but God still held accountable those who mistreated her.

> **READ PSALM 3:3** and use it as a prayer prompt of assurance and thankfulness that you are surrounded by God.
>
> Dear God,
>
> _____
>
> _____
>
> _____
>
> _____
>
> _____
>
> Amen.

You are surrounded by the love and care of God, my friend. No matter what else surrounds you, God is greater.

Good stuff today. Tomorrow we are heading to Edom!

Start packing. See you there!

Day Three

ON THE HOOK

Bitterness does more harm to the vessel in which it is stored than the vessel on which it is poured.

Author unknown

I'm at my standing desk today, walking in place while I write this. (I'm afraid I've eaten a few too many Famous Amos cookies, and it's only Invitation One!) I wonder where you are while you study Amos with me today. If you get a chance, post a pic and tag it with #AmosStudy so I can say, "Hi!"

Well, we're only dealing with one nation today, but you're familiar with it because the name came up twice yesterday. It's the fourth of the six enemy nations Amos was calling out. You can find it in Amos 1:11-12.

Before we get started, let's pause and ask God to guide our thoughts today.

Lord, we trust You to teach us Your truth. We are open to learning. Amen.

Let's get clear about the who, why, and what of today's nation. Read the verses and fill in the chart.

	NATION	SIN	JUDGMENT
AMOS 1:11-12			

Do you wonder why the nation Edom gets a whole day of study all to herself? Well, sister, the Edomites are like family. Yep, estranged, angry, bitter family! Let's do our own simplified version of Ancestry.com® because as we understand who the Edomites are, it will teach us a lot about who we are.

According to Genesis 36:1,8,19,43, from whom did the Edomites descend?

Esau was the progenitor of the Edomites. Seems it was pretty important for Moses to make this clear in Genesis 36 since God had him mention it so many times!

According to Genesis 25:20-26, who was Esau?

Esau and Jacob were twin brothers, the sons of Isaac, grandsons of Abraham. To trim up this family tree, Esau became the nation Edom, and Jacob became the nation Israel. Got it? *Whew!*

Based on Numbers 20:14-21, check the phrase that best describes what happened to propel them into constant conflict.

☐ **Esau left a note in his will telling the generations to come to avoid the descendants of Jacob.**

☐ **The Israelites raided the Edomites and overtook their livestock and water supply.**

☐ **The Edomites wouldn't let the Israelites pass through their territory en route to the promised land.**

☐ **Esau and Jacob fought bitterly over the same girl, and the rivalry trickled down through the generations.**

The Edomites refused the Israelites passage through their territory. It was petty and small. Evidently, this was where the conflict started, but it kept up for years. The Edomites fought against King Solomon (1 Kings 11:14), and they opposed King Jehoshaphat (2 Chron. 20:2). Even in Psalm 83, Edom tops the list of enemies.

So now we have two nations that aren't getting along. And you thought your family gatherings were stressful!

Amos affirmed through Edom's judgment that God will avenge His children when they are treated with hostility, anger, or held hostage by hatred. But Edom also shows us that what we hold onto long and tightly enough eventually will hold us in its death grip. Amos's prophecy came true in the fifth century BC when Edom was removed from Petra.[16] The Edomites would later disappear from history completely, marking their total destruction.

But the fire that eventually consumed them really just served as an outward picture of the daily heat that hate kindled in their hearts for years. Hate is a slow death. It kills relationships. It kills potential. It kills the good life. God judged them for their unwillingness to show brotherly responsiveness and forgiveness. He took it that seriously.

In fact, Amos wasn't the only one God used to pronounce judgment on Edom.

CHECK OUT OBADIAH 12. What were the Edomites accused of?

The Edomites gloated at Israel's misfortune. They got a buzz out of Israel's hardship. Instead of lifting Israel up when she really needed it, Edom stomped on her. The Edomites showed no brotherly compassion, and, eventually, they got what they gave.

> Sister, if you have been wronged or held hostage by someone's bitterness, you can live assured that God will hold responsible those who hold you in contempt. Pause and pull out your mirror. Not literally! I mean, take a look into your own soul. Are you clinging to some bitterness, contempt, or anger toward someone?

When I look at myself, I have to ask, does God take it that seriously when I hold on to an offense, when I choose bitterness toward one of His children rather than brotherly love?

Oh, yeah, He does.

THE GOD LIFE IS ONE OF BROTHERLY LOVE.

Choosing unforgiveness and holding onto hate or bitterness against someone who sinned against me is wrong. It is just as wrong as the sin perpetrated on me. I am like Edom when I choose to hold onto bitterness and withhold sisterly love. How does that hit you?

> Maybe you need to pause, sit with the Lord for a moment, and ask yourself some hard questions:
>
> *Am I holding onto hate or bitterness toward someone who has wronged me?*
>
> *Is it right for me to hold onto that wrong?*
>
> *How does it hurt me to hold onto bitterness?*
>
> As you ponder those questions, ask God's Word to inform your feelings and thoughts. Read the passages on the next page and jot down what they say about brotherly love.

Mark 11:25

Romans 12:10

Ephesians 4:32

Hebrews 12:15

1 Peter 3:8

I know choosing kindness, compassion, and forgiveness is hard when you've been hurt. I get it. There's a human in my life with whom I am in constant forgiveness mode because in our relationship I so quickly choose bitterness and start writing out my "record of wrongs"! But the good life is one of brotherly love. And we can live assured that God cares and sees and will hold accountable those who wrong His children. Knowing this, we can let those who wrong us off the hook. That doesn't mean we have no boundaries or call wrong right—no way. As my friend Stormie Omartian says, "Forgiveness doesn't make the other person right, it makes you free."[17]

Review the list of the actions described in the brotherly love passages above.

Now ask God to give you grace to live out those actions! If there's a human whom you have held on the bitterness hook or a human whom you feel is holding you hostage to his/her own bitterness, ask God how you can show brotherly love—even if it's only in your attitude and prayer. Then as He shows you, live in obedience.

Ultimately, brotherly love looks like Jesus—like laying down your life for another.

That is what the God life does; it chooses brotherly love. And when we live assured that God has got us, we live the good life.

Keep on loving each other as brothers and sisters.
Hebrews 13:1 (NLT)

All right, I'm ready to go live what I've learned. Good job today! See you tomorrow!

Day Four

NEVER OVERLOOKED

The eyes of the LORD are in every place,
Watching the evil and the good.

Proverbs 15:3

———————————

Four nations down, two to go! Way to go, you! You've made it through almost all the judgments on the enemies of Judah, and I hope you've been as encouraged as I have. Today we will finish up Amos 1 and hit the start of Amos 2 as we learn about Ammon and Moab.

Lord, please guide our time with You in Your Word. Teach us, Holy Spirit. Amen.

READ AMOS 1:13-15; 2:1-3. Let's finish up our chart!

	NATION	SIN	JUDGMENT
AMOS 1:13-15			
AMOS 2:1-3			

Wow. These are the most graphic sins so far. Once again, not very pretty, is it? Let's examine each nation's sin to help us grow in assurance that God sees and cares.

AMMON

Do you remember on Day Two you read that Gilead, which belonged to Israel, was threshed by Damascus? Well, here they are in another enemy's sights. Ammon attacked Gilead, and the description Amos gave of what the enemy did was horrible. Their brutality included killing babies in the womb. In antiquity, this was a depraved practice of war intended to intimidate and strike terror in those being attacked.

Did you notice God didn't call out any other specific practice of war, though? Why do you think He led Amos to call out this one act?

God will avenge the helpless, unborn, voiceless, and vulnerable.

> **FIND PSALM 10.** It echoes how we feel when evil seems to go unchecked, but it also affirms God's judgment will prevail. Read it, noting how often you read the words *helpless* or *innocent*.

> After you read the whole psalm, focus on verses 8-10 and describe how the helpless are mistreated.

Sounds a lot like what Ammon did, doesn't it?

> **NOW FOCUS ON VERSES 14-18.** Describe God's response to the helpless.

Psalm 10 probably sounds a lot like your prayers when you see the unborn so easily discarded and the physically defenseless disregarded. It sure echoes mine: "Why, LORD, do you stand far off? Why do you hide yourself in times of trouble? . . . Arise, LORD! Lift up your hand, O God. Do not forget the helpless" (vv. 1,12, NIV).

My sister, God knows the hurts of the helpless, He hears their cries, and He will ultimately bring justice. When you feel discouraged over the state of the helpless, pray Psalm 10 and ask God how you can be an answer to that prayer. Ask Him for the courage of Amos to respond to what He calls you to do.

Before we move to the last nation, let's affirm our faith with what Psalm 10:16 says about God and the nations.

God is: _____.

Nations will: _____.

Girl, I know we can feel discouraged by the evil that goes on in our world and how it seems unchecked and unfettered. But injustice and evil will not be here forever. God is King forever! Nations will be obliterated. And Ammon is a good example of this. Ammon was taken down by King Nebuchadnezzar in the seventh century BC.

Thank You, Lord, that we can trust You to vindicate the helpless and unborn.

Now you may want to grab a diet soda or some strong coffee for our last nation. We're almost done!

MOAB

Review the chart you filled out earlier (see p. 28) to refresh your memory about Moab—what the Moabites did and what consequences they would suffer.

Did it strike you as odd, as it did me, that God, who had just condemned the Edomites a few verses ago, now looked like He was standing up for them concerning the treatment of their dead king? *Hmm.* Does this mean Edom was exonerated?

Let me give you the brief backstory and then you can decide what all this means. Moab and Edom were entangled in a long-standing feud. They were sworn enemies. So the Moabites decided to dig up the bones of a long-dead Edomite king and throw his bones into a fire, torching them to ash. This was done out of pure spite and malice and, of course, was totally offensive to the Edomites.

Why was God calling this out? What do you think this sin represents?

If you're not sure, here's another question: Can a corpse fight back? Well, of course not. What do you think the principle is?

Like Ammon, Moab's actions were just one more ugly example of taking advantage of someone weak and defenseless. You can live assured that God doesn't take lightly those who hurt the vulnerable or destroy those who can't defend themselves. God's justice is no respecter of person or nation. He even avenged sin perpetrated on the enemy nation Edom because sin is sin; wrong is wrong. A righteous God must righteously respond to sin. These ancient nations bumped up against the righteousness and justice of God and were crushed by it.

Sister, even when it looks like evil flourishes, you can live assured God does not overlook sin.

Describe the principle communicated in Deuteronomy 32:32-35.

Vengeance belongs to God, and He alone determines the timing. That means we can live assured that He's got this! We can even lighten up, live the good life, and rejoice. Rejoice?

Skip down a few verses to verse 43 and list the three reasons for rejoicing that God gives.

1. _____

2. _____

3. _____

God will avenge the blood of His servants, take vengeance on His enemies, and cleanse the land for His people. I love that! I know this is in the context of what God will do for Israel, but the principle of God's goodness toward His people will be fully seen through the atoning work of Christ on our behalf.

How can you personalize the principle so it gives you assurance with what is going on in our land and in your own private world?

God will _____

_____.

God sees and cares about how the helpless, the defenseless, and all of His family are treated. We are His, and we can live assured that vengeance is God's. Our Lion of Judah "roars from Zion" (Amos 1:2), and He will make "justice roll out like waters, and righteousness like an ever-flowing stream" (Amos 5:24).

Lord, may the stream of Your justice wash over us and cleanse us. May we be carried on the current of Your righteousness. Thank You that You see, care, and vindicate. May the care we receive from You flow through us to cleanse and carry the helpless and oppressed. Amen.

Well done, my friend! You made it through the first invitation of study. Tomorrow will be our first "Good Life Day." It's lighter and will help you live out what you learn.

Love,

Jennifer

Day Five

YOUR GOOD LIFE DAY

Lord, I receive Your invitation to live assured.

What would my life look like if I lived assured that God sees and vindicates His children?

What choices can I make to accept God's invitation to trust Him with my enemies or struggles?

This week, God taught me . . .

MY GOOD LIFE DECLARATION

To live the good life, I will live the God life and . . .

I will let go of:

I will trust God with:

I will take hold of:

To make your Good Life Day even better, listen to my #GoodLife playlist at jenniferrothschild.com/amos.

INVITATION ONE:
Live Assured

To access the video teaching sessions, use the instructions in the back of your Bible study book.

BEFORE THE VIDEO
Welcome and Prayer

VIDEO NOTES

Israel was surrounded by enemies, but God was assuring her of

His _____, _____, and _____.

FOUR THINGS WE CAN DO WHEN WE FEEL SURROUNDED:

1. Feel the _____ but focus on the _____.

2. Pray for _____.

> When you feel surrounded, if you don't pray for _____, you'll miss seeing what's really going on.

3. Avoid _____.

4. Show _____.

> Your happiness, your thriving in life is based _____ on how people
>
> treat you and _____ on how you treat others.[18]

You can get my written summary of this video message emailed to you by going to jenniferrothschild.com/amos.

CONVERSATION GUIDE

DAY ONE: Do you feel qualified to do what God has called you to do? Explain. What are some things you allow to hinder you from serving the Lord? How would you compare the religious climate in Amos's day to the spiritual climate in the church today? If you sense the church is drifting from true worship, are you confronting or contributing to that drift? Explain.

DAY TWO: How have you sensed God's protection and presence surrounding you in the last few days? How has He been the glory in your midst? What helps you leave vengeance and judgment to God when you deal with the wrong done to you and wrong inflicted upon the world?

DAY THREE: How have you seen hate wreak havoc in your own life and the lives of those around you? Why is it difficult to let go of the bitterness and hate we harbor? What steps can you take to express brotherly love to those you find difficult to show love?

DAY FOUR: Do you ever feel like God is far off and not paying attention to the injustices taking place around you? Explain. How can you know that's not true? How can you pray about these injustices? And how does God want you to be an answer to your prayer?

VIDEO: Why is focusing on the facts so important when you feel surrounded? Your happiness and ability to thrive in life is less about how you're treated and more about how you treat others. Do you agree or disagree? Explain. How have you seen this be true in your life? What is something God taught you this week? Why is it so important that you accept God's invitation to live assured?

INVITATION TWO

YOU ARE INVITED TO

Live Faithful

Day One

EMBRACE GOD'S WORD

We must allow the Word of God to confront us, to disturb our security, to undermine our complacency and to overthrow our patterns of thought and behavior.[1]

John Stott

Welcome to Invitation Two and Amos 2! I made a decision. I've eaten my last Famous Amos cookie for now, and I'm switching them out for dried figs instead. I love fresh figs! My mom has a tree in her backyard, and nothing is better than biting into a sun-kissed fig fresh from her tree. But, alas, since I'm way too many miles away from that tree, a dried fig picked straight from a bag off a Walmart® shelf is the next best thing. I think nibbling on figs while studying Amos is fitting, don't you? After all, Amos was a "dresser of figs"! Besides, they're good for our bones and cholesterol. Unfortunately, I can't say the same thing about chocolate chip cookies! Have you had a fig lately? Well, you may just need to pause and order some or run to the store and grab a bag. Go ahead—I'll wait! It may just make this week of study even sweeter!

Lord, thank You for all Your goodness. We thank You for the sweetness of a fig and the nourishment of Your Word. Feed us with Your Word today. Amen.

ALL RIGHT, FIND AMOS 2:4-5. When you read it, you'll see that Judah was now feeling the heat. Describe what God, through Amos, called them on the carpet for.

Before we deal with the details of their sin, let's start with the fact that this is a bummer, isn't it? God's chosen people are getting hammered with the same "three . . . even for four" judgment formula as the enemy nations did last week. That means Judah had been busy piling on the sin too.

Since God calls us His own, just like He did Judah, pause and consider your potential when it comes to sin.

List what the following verses say about our sin risk:

Proverbs 16:18

1 Corinthians 10:11-13

James 1:14-15

Oh, girl, just like Judah, my pride is all it takes to send me into a sin spiral. And when I just flat out give in to my unguarded, misguided selfish desires, I am planting little sin seeds that eventually grow and choke me. And if that isn't bad enough, if I get too self-assured, I'm putting myself at risk for a big fall. That's true for you too. But God will give us a way out. We don't have to fall for or into the sin. We don't have to settle for the "three . . . even for four" pileup when it comes to sin. So, if you are busy digging a big sin hole and piling it on, sister, this is your day to pause, consider, change your mind, and agree with God about sin. Ask Him to forgive you and cleanse you. He will.

PRAY 1 JOHN 1:9 and then celebrate the good life of forgiveness and move on! You may want to make a note here of your prayer of repentance and God's forgiveness so you can refer back to this marker day.

OK, moving on, let's examine the details of Judah's sin because it's an easy sin to slide into.

LOOK AT AMOS 2:4 AGAIN. Circle which response best fits. By the way, I'm studying from the New American Standard Bible.

1. What did Judah do with the Law of the Lord?

 Kept it. *Rejected it.* *Ignored it.*

2. What did Judah do with God's statutes?

 Overlooked them. *Kept them.* *Disobeyed them.*

3. How did Judah handle lies?

 Rejected them. *Followed them.* *Believed them.*

Ouch. They rejected God's Law, they didn't keep His statutes, and they let lies lead them astray. They followed the same lame lies as their fathers.

God's "Law" or "statutes" is the same as God's Word. It is His truth for His people. Judah had been given God's precious Word, but they rejected it. The King James Version says they "despised" it. And what they despised, they dismissed, ending up deceived and disobedient. That's an interesting progression, isn't it?

> **Let's pause and ponder a few of those words. Grab your dictionary or look at an online dictionary and write the definitions below in first person phrasing:**
>
> **To *despise* means I** _____
>
> **To *dismiss* means I** _____
>
> **To be *deceived* means I** _____

Wow, did you see that progression? Judah showed contempt for God's Word. That led them to reject it. Then with no standard of truth to cling to, they followed the falsehoods.

Because you are smack dab in the middle of doing a Bible study on one of the most overlooked books in the Bible, it might seem like you aren't despising or dismissing God's Word. But look at the definitions you just wrote in first person. Ask yourself: *Are any of those statements true about me when it comes to God's Word? Have I ever rejected God's Word?*

If you asked me, "Jennifer, have you ever rejected God's Word?" my first answer would be "No way. I love His Word. I would never reject it." But, girl, I have neglected it a million times in the past, and I am ten seconds away from getting distracted or disinterested even now. I am prone to wander! And when I neglect God's Word, I am quick to fall into lies. I share that with you because you may be prone to wander too. That is why we embrace God's Word; we trust its truth. Even if it's one verse a day that you cling to, embracing God's truth keeps you from the clutch of sin's lethal lies.

WHEN WE HOLD ON TO TRUTH, TRUTH HOLDS US SECURE.

Amos pointed out that Judah's big sin was neglecting and rejecting God's Word. Sister, the longer I live, the more convinced I am that even neglecting truth is a form of rejecting it. Sin is rarely a big leap. It is most often a series of micro choices and then, *bam!* We find ourselves feeling the heat our neglect invited.

What was the result for Judah?

LOOK AGAIN AT AMOS 2:5.

The fire of God's judgment was to fall upon Judah. And though this was likely a nod toward the judgment they'd experience years later through Babylon, it still has a spiritual meaning for us today.

Where does 1 Peter 4:17 suggest God's judgment should fall first?

Sometimes we get all worked up at the sin of the sinners! We read or hear the news and complain about how lost people act like lost people—they make wrong choices, hurt others, elevate themselves, and do all sorts of evil in the name of freedom. If you're like me, when you see that, you may feel tempted to get a little judgy. But why should I expect lost people to act any other way than lost? Why should I expect unrepentant and/or ignorant sinners to behave any differently than sinful? I shouldn't. I am not being a fatalist here. I want more for those who do not yet know Jesus, those who have not yet accepted their invitation to the good life. The point I'm making is that maybe I get judgy and focus on the sin of other sinners so I don't have to pay as much attention to my own sin or the wrongs in my own Christian community.

Perhaps we should first pay attention to our own house. Let judgment start at the house of the Lord, as Peter described. You and I are invited to live faithful, and that begins with embracing God's Word. When we truly embrace God's Word, His living and active Word gives us life and draws out righteous action in us. When we embrace His Word, it chokes out our pride and ushers in humility. Besides, embracing God's Word comes with all sorts of free gifts, too!

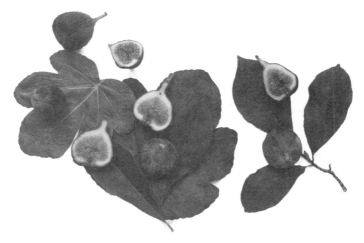

Let's finish our time together with a treasure hunt in Psalm 119. You can read the whole chapter and pull out the verses that point out the benefits, or you can just read the verses I've listed here and jot down the benefits you find. You will love this!

PSALM 119:2: When I keep His statutes,
I am _____.

PSALM 119:9: When I live according to His Word, I stay on the
path of _____.

PSALM 119:11: When I hide God's Word in my heart, I am protected from
_____ against Him.

PSALM 119:36: When my heart is turned toward His statutes, I won't be
turned toward _____.

PSALM 119:45: When I seek out God's precepts, I will walk
in _____.

PSALM 119:99: When I meditate on His statutes, I gain

_____.

PSALM 119:104: As I gain _____ from His Word,
I avoid _____.

Talk about the good life! Sister, as we embrace His Word, we are blessed, we are wise, we gain understanding, we avoid sin and selfishness, and we walk in freedom! Bring it on!

Lord, we declare with the psalmist, "I delight in your decrees; I will not neglect your word" (Ps. 119:16, NIV). God of Amos, thank You for Your Word. "Never take your word of truth from my mouth, for I have put my hope in your laws" (Ps. 119:43, NIV). Our hope is in You. Amen.

Well, that was a quick stay in Judah. Tomorrow we are off to Israel.

Day Two
TREAT OTHERS RIGHT

Character is doing the right thing when nobody's looking. There are too many people who think that the only thing that's right is to get by, and the only thing that's wrong is to get caught.[2]

J. C. Watts

———————

Well, hey there, sister! We're still in Amos 2 today, and we'll look at verses 6-8. Before you even read it, I will tell you it starts with the same sorry song: for "three . . . even for four!" Are you tired of that out-of-tune lyric yet? Me too. Israel piled on the sin, just like the Gentile nations and Judah did. Now it was the Israelites' turn to feel the heat. We can imagine Amos standing near the glow of the golden calf in Bethel and beginning his pronouncement of judgment on the Northern Kingdom.

But before Amos started singing the eighth verse of this judgment song, consider the following: It's likely the curious Israelites heard Amos condemn all those nations that surrounded them.

Damascus condemned. Yes! (Israelites fist pumping.)

Gaza condemned. Yes! (Israelites roaring with glee.)

Tyre condemned. Yes! (Israelites high-fiving.)

Edom condemned. Yes!

Ammon condemned. Yes!

Moab condemned. Yes! (Israelites' hands raised in victory.)

Then, even Judah condemned. (Israelites nodding their heads in smug satisfaction over the judgment on their pesky Southern sister.)

Don't you know the Israelites were loving hearing all this? It had to make the Israelites feel like old Amos was not so bad and God was clearly on their side. But then the soundtrack changed to an ominous minor key as Amos turned his preaching toward them.

READ AMOS 2:6-8.

The reason we want to examine this passage is not to gloat or look down our pious noses and give a "tsk, tsk!" No way. We're looking at these condemnations so we can flip them on their heads and see the invitation that lies beneath! Israel was condemned for doing the wrong things, so we want to see these condemnations as invitations to do the right thing instead.

Lord, we want to live faithful and humbly receive Your Word that You impart to us. Amen. (See Jas. 1:21.)

Before we deal with the stinky specifics of the sin pileup in Amos 2:6-8, let me remind you of the scene. Israel was bursting with prosperity about now. She was militarily secure and life was good as far as the Israelites were concerned. In fact, not only were their bank accounts bursting, but so were their buttons! They were puffed up and full of pride. And into this Northern Kingdom eliteness, fig farmer Amos started to preach.

> **Amos 2:6-8 gives us a picture of the Israelites' priorities. How would you describe them based on these verses?**

It seems they valued their prosperity over the poor; they elevated themselves by pushing down those who needed a leg up.

> **In Amos 2:6, what did God, through Amos, specifically condemn?**

Amos was using some poetic language when he condemned Israel for trading the poor for sandals and silver, so let me boil it down for us! Based on the original Hebrew language, this is likely referring to bribing judges and enslaving people for their debts.[3]

In fact, look at Amos 2:7 again. Your version probably reads something like, "They trample the heads of the poor on the dust . . ." (CSB). But the New King James Version reads that "they pant after the dust of the earth which is on the head of the poor." This is not dandruff dust here! The Hebrew for the word *pant* refers to sniffing the ground like an animal might when chasing prey.[4]

What does that Hebrew meaning suggest to you about how the Israelites treated the poor?

To me, it sounds like they honed in on exploiting the poor however they could. They were looking to take advantage. It shows an appetite for cruelty.

But we're not done yet! What was happening in Amos 2:8a to display this same cavalier attitude?

READ EXODUS 22:26-27 AND DEUTERONOMY 24:10-13 to understand why they were called out for this action.

These verses describe how the lenders or government officials were not to keep the poor man's cloak overnight because the poor were not to be cold and unsheltered. But Amos 2:8 confirms that was exactly what was happening. And the wine of the condemned mentioned in verse 8 represents the punitive damages that were supposed to go to the violated, but instead, the jurists sucked it down with big gulps of entitlement. They were blatantly breaking God's laws and hurting people in the process.

Proverbs 22:16,22-23 summarize Israel's behavior. How would you use those verses to tweet about Israel's status? What juicy hashtags would you include (e.g., #BadChoiceIsrael)?

OK, one last sin. It's the uncomfortable picture in Amos 2:7b. You thought I forgot or had purposely skipped over that weird lust triangle? No, sister. I wish! Amos 2:7b says, "A man and his father go in to the *same* girl, To defile My holy name" (NKJV). Ugh. This

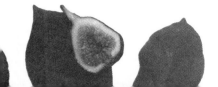

rated R activity could be referring to pagan temple prostitutes.[5] With all these accusations, Amos was raising a larger issue than just certain people with certain sins. He was pointing out a culture of immorality, idolatry, indulgence, entitlement, and exploitation. It is all so ugly, isn't it? Yet, as defiled and broken as the humans are because of their participation or exploitation, the Hebrew language teaches us something sobering at the end of Amos 2:7.

According to the end of verse 7, what is the result of the lust triangle?

God's name is profaned. The Hebrew preposition indicates purpose or intention.[6] So the sexual perversion and exploitation of the poor were "in order to" or "for the purpose of" dishonoring God.

OK, yellow light. Let's pause and think about this. As far as God is concerned, they were violating His laws in order to, with the intention of, insulting Him. *Ugh.* Do you think when the father and son got all lusty and headed to the temple for an idolatrous adulterous tryst that they were actually thinking, *I think I will sin big time in order to dishonor God?* It's hard for me to believe they were even thinking at all!

OK, stay at the yellow light and consider one more Scripture before we pull all this together: Proverbs 14:31. Rephrase the first part of that verse into a first-person sentence: If I _____, then I _____.

If I oppress the poor, I taunt God. I dishonor God. I insult God. Whether it is sexual sin or selfish hoarding or intentional exploitation, sin isn't just a personal thing between me, myself, and I. Sin is personal to God. It profanes His name. It dishonors Him. It is not just about us, just like it wasn't just about Israel. I don't like to think of my sin as a direct, intentional insult to God. I want to just think of it as my own little personal weakness or bad behavior that only affects me. But my choice to sin is a tacit choice to dishonor God.

Pause and ponder that for a minute. Don't move on until you feel like you've got a right understanding of how your sin affects your God.

I don't want to dishonor my Father God. I love Him. He has invited me into more than a life of selfishness or sin. And I know you feel that way too, sister. To live faithful, we treat others right, and that includes treating God as He deserves, with honor, through a pure heart and righteous action.

Now, you may be thinking, *This study is an invitation to the good life? That last paragraph wasn't so good or inviting!* I know. I get it. But it is! Sit up straight and smile because I'm about to tell you why.

You sin. I sin. We "all have sinned and fall short of the glory of God" (Rom. 3:23). (That wasn't the smile-worthy info yet.) A holy, righteous God must judge sin. Israel was being judged because of her sin and unwillingness to repent. So far, not good news, right? But now move up to the edge of your seat, because here comes the good news. (This is where the soundtrack of your life changes keys! The strings swell, the trumpets blast, and suddenly every dissonant chord is resolved!)

Jesus took God's judgment of sin for you because He became sin for you.

READ ROMANS 3:25-26.

READ 2 CORINTHIANS 5:21.

READ GALATIANS 3:13.

Now get on your grateful knees and thank God who gave you Jesus and the good life! We are invited to live faithful, pure lives through the forgiveness, grace, and strength of Jesus.

What you are invited to through Amos today is summed up in Psalm 34:12-14. Read it and then rewrite or personalize it into a declaration of how you will live the good life!

Take a picture of what you just wrote and share it with me on Instagram or Twitter @JennRothschild so I can celebrate this good life with you. Be sure to use the hashtag #AmosStudy when you post!

Sister, may we love life and enjoy many good days as we live faithful, treat others right, and treat God as He deserves through our pure lives. Amen!

For the LORD your God is the God of gods and the Lord of lords, the great, the mighty, and the awesome God, who does not show partiality, nor take a bribe.

Deuteronomy 10:17

I'm cheering you on! See you tomorrow!

Day Three

REMEMBER GOD'S GOODNESS

Remembering the goodness of God in the past, will help us in seasons where it's harder to *see* Him.[7]

Esther Fleece Allen

Hey, sister! So far this week we've talked about two ways to live faithful and live the good life—embrace God's Word and treat others right. I love how practical the Bible is, don't you?

Today we're staying in the practical zone, and it's all about sharpening our spiritual memory. Remembering God's goodness helps us to live faithful because—*dramatic pause*—the more we become forgetful, the more we become unfaithful.

Can't have that, sister! We are invited to live faithful, and we want to accept that invitation to the good life! So pour your coffee, or whatever tastes good to you, pop a fig in your mouth, and find Amos 2:9-11. Before you read, pause and pray Psalm 119:18, *"Open my eyes that I may see wonderful things in your law" (NIV).* Amen.

> **Based on Amos 2:9-11, which of the following phrases best represents what God was doing for Israel?**
>
> *Reprimanding them. Reminding them. Redeeming them.*

God reminded His people of what He had done in the past because it represented His power and faithfulness to them. We need the same kind of remembering, don't we?

LOOK AGAIN AT AMOS 2:9-11. Write beside each reference below the specific detail God brought to their attention—because details matter.

Amos 2:9

Amos 2:10

Amos 2:11

God reviewed little detailed facts to help reinforce the big fact of His faithfulness. Specificity matters when it comes to remembering broad truths. Did you get that? Sounds like I just contradicted myself, but nope. Here's why.

Let me illustrate by giving you a glimpse into my marriage.

I married my husband, whom I affectionately call my very own "Dr. Phil" (this is because he's a professor), in 1986. For the last thirty-something years, I've never once forgotten I'm married. He's my husband. I even remember to acknowledge that fact every August 9.

I never forget that big fact, but I sometimes don't remember what that big fact means to me. Some days I get frustrated with him. Sometimes I don't treat him like I should. Sometimes I feel impatient with him. Some days I get complacent and busy and the fact that he is my one and only all-around amazing stud husband, who loves me and takes care of me and—*deep breath*—would give his very life for me, doesn't impact me one bit. Not. One. Bit.

Now, that is a downright embarrassing admission right there! Is it because I love him less now than when I said, "I do"? Nope. I actually love him tons more. It's because my feelings are forgetful.

If I stop and think about some of the details about him and memories of our life together for even just a minute; if I think back to that hot August day in Florida when he wore a goofy smile and a gray tux and vowed to love and cherish me; if I remember him at twenty-something with his bushy curly blond hair and his Tom Selleck shoulders; if I recall him in the labor and delivery room hyperventilating as he tried his best to breathe with me as I delivered our first son, those recollections of the past start to reshape my feelings in the present.

If I think about how funny he thinks he is when telling dad jokes and how he will spend ridiculous amounts of time searching for the "best deal"; if I pause and review things he's said, places we've gone, and kindness he's shown, then all of the sudden I am smitten all over again. Remembering all those little details suddenly brings to life the broad truth that

he is my faithful husband. When I ponder all those particulars, I get all warm and yummy toward him! I feel drawn to him. It refocuses me. It recalibrates my heart.

It doesn't matter if you're married or single. You know what I'm talking about, right? Sometimes we just need to pause and remember the details, to get specific about who our God is, who He is to us, and what He has done for us.

In Amos 2 it might be easy to hear God list the details of His faithfulness as a shaming "How could you forget after all I've done for you?" kind of list. But when I consider God's merciful and long-suffering character, I think He spoke it with a wistful broken heart, and it's just another way God is setting the example for us.

Intentional remembering can lead to intimate reconnecting, and recollections of the past can reshape feelings in the present.

THE GOOD LIFE IS ONE OF REMEMBERING.

Just like you detailed each fact about God's faithfulness to Israel in Amos 2:9-11, I'm going to give you the chance to do the same with your own life. Take some time to just plain remember the goodness of God! Think about how God's faithfulness has shown up in your life. I know your big answer is through your salvation in Christ, but I want the juicy details!

> **Walking through the verses we just read (Amos 2:9-11), journal your own details about how God has been faithful.**

> **In Amos 2:9, God reminded the Israelites that He conquered the Amorites for them. Describe a time you faced something or someone that felt like the Amorites to the Israelites. You know, an adversary? Something bigger than you? A situation or a person that felt like an enemy you just couldn't stand up against because it all seemed so daunting?**

How did you see God's power or faithfulness when you faced your own "Amorite"?

In Amos 2:10, God reminded the Israelites that He rescued them from Egypt, led them, and gave them the promised land. Have you ever felt enslaved or stuck like the Israelites in Egypt? It could be a destructive habit, an addiction, an unhealthy or abusive relationship, or even self-hatred or low self-esteem. All those things can feel like you're in a foreign land where you can't get free or unstuck.

How did God bring you, or how is He bringing you, out of your Egypt? Describe how He led you or is leading you. Then detail how God faithfully kept His promise to you.

Finally, in Amos 2:11, God reminded the Israelites that He had raised up their young men to be prophets and Nazarites—godly influencers who would show them and teach them the way of the Lord. (But unfaithful Israel silenced them and sabotaged them in Amos 2:12.)

Who were some of the men the Israelites probably would have thought about when they heard this?

Yeah, guys like Moses, Joshua, and Samuel would have come to mind as prophets. Samuel was also a Nazarite, as was Samson.

Now consider this: the prophets led and taught the things of God, and the Nazarites were examples of self-control and holy living.

> **Who are the people in your life, or the people you observe, who serve as living details, like prophets and Nazarites, that show you God's faithfulness and power?**

You know, I bet there are some names of people you wrote down who need to hear how they have been examples of God's faithfulness and goodness in your life.

> **Take a minute to call, email, text, or write a note to them. Or you can post about them on social media with #AmosStudy so all your Bible study buddies will see it. Even if you don't want to reach out to your "prophets" and "Nazarites" right now, pause and pray for them and thank God for showing His faithfulness through His people.**

Wow. Did you see how you just chronicled times and people that make up the good life? You just spent some quality time remembering God's faithfulness in detail. Important reminder: forgetting to remember God's faithfulness to us in the past can make us forget to be faithful to Him in our present.

That was what God, through Amos, condemned the Israelites for. And that serves to show us what God is inviting us to—a life of remembering.

Remember the good things of God, sister girl. I know life can be hard and messy, but God has been faithful, and He will be faithful to you. So be a "good life list maker"! Write it down when a good thing about God comes to mind. Your feelings may be forgetful some days, but you can refer to your list and recalibrate your feelings and reconnect with your God.

I've forgotten what the good life is like. I said to myself, "This is it. I'm finished. God is a lost cause." . . . But there's one other thing I remember, and remembering, I keep a grip on hope. God's loyal love couldn't have run out, his merciful love couldn't have dried up. They're created new every morning. How great your faithfulness!
Lamentations 3:18,21-23 (The Message)

Well, my coffee cup is empty, and my heart is full! See you tomorrow.

Day Four
COUNT THE COST

For the wages of sin is death, but the gracious gift of God is eternal life in Christ Jesus our Lord.

Romans 6:23

———————

"You are wearing me out!" That was my exasperated announcement as I stood at the top of the stairs. After five whole minutes of coaxing and commanding, not one thing changed! Lucy, my little diva dog, just stayed firmly planted at the bottom of the stairs, whining and emitting intermittent low growls. It was as if she was saying, "Get down here and carry me up those stairs! You really don't expect me to respond to your lame promises of treats and blustery commands to get me up those stairs, do you?" The girl was steadfast and immovable for sure.

Lucy is an elderly shih tzu who, even in her younger years, had quite the attitude! Now that she is a geriatric, her diva demeanor is almost unbearable. I will put it this way: I am grateful she lets me live in her house! She wears bows and scarves that coordinate with each season of the year, gets her hair and nails done every six weeks, and literally prances when we walk her. She swings her perfectly coiffed tail back and forth as if she, and she alone, is keeping rhythm to her own epic soundtrack that plays every time she hits the pavement. I love Lucy! With all my heart I love that silly dog. But, sister, she can be a little draining. Granted, the old girl has trouble seeing to climb stairs, and I bet her hips hurt too. But still, she can wear a woman out with all her demands!

So, "You are wearing me out" were my last words as I gave up and left the whiny baby at the foot of the stairs. I then sat down at my computer to study Amos. And behold! Amos 2:13-16 was next in line. Go ahead and read it now. Note especially verse 13: "Behold, I am weighed down by you, As a cart full of sheaves is weighed down" (NKJV).

Was God saying the same thing to Israel that I said to Lucy? Were the Israelites wearing Him out? *Hmm.*

Pause and ask God to make His Word come alive through His Holy Spirit as you study today. Thank You, Lord, for being our Teacher. Amen.

OK, back to the question. Were the Israelites wearing God out? Is that even possible? Read the following Scriptures and jot down what each suggests about God feeling burdened and worn out.

Isaiah 40:28

Isaiah 43:24

Malachi 2:17

Interesting. Isaiah 40:28 says God does not grow tired or weary. Yet Isaiah 43:24 and the Malachi passage both say God has become wearied. It seems God does feel the weight of our neglect and is burdened by our sin. He is also wearied by hollow and untruthful words.

Now, is it only me, or does that seem odd to you? Like, how can a self-existent, immutable God, who does not grow weary, become wearied by the weight of His people's stuff?

Well, time for a geek moment that will explain this. And it will also make you love God even more. Bible scholars say there are two possible ways to look at this.

INTERPRETATION ONE

The Lord felt weary under the burden of Israel's sin like a wagon feels weighed down when it is piled high with grain. In other words, God felt the weight, the burden of Israel's sin. He was not physically tired or emotionally exhausted, but His patience was being challenged.

INTERPRETATION TWO

Israel was to be burdened, crushed as if under the weight of a heavy wagon full of grain. Israel would be pressed into place just like the ground underneath a heavy cart which smashes anything it rolls over.[8] (In fact, if you're reading Amos in a CSB, ESV, or NIV Bible, that interpretation is reflected in the wording.)

Based on what you've studied so far in Amos, which interpretation seems like the best choice to you and why? (Don't be intimidated; just answer with your gut feeling. There's no wrong answer here!)

I think either interpretation could be valid. Interpretation two works if you see the passage as another way Amos was saying God would bring judgment upon the Israelites, put them in their place, straighten them out. And Matthew Henry, my favorite dead commentator, may just agree: "If God loads us daily with his benefits, and we, despite that, load him with our sins, how can we expect any other than that he should load us with his judgments?"[9]

But interpretation one also works because of the original Hebrew. Albert Barnes, my second favorite dead commentator, wrote, "His long-suffering was, as it were, worn out by them. He was straitened under them, as the wain groans under the sheaves with which it is over-full. The words are literally, 'Behold I, I' (emphatic I, your God, of whom it would seem impossible) 'straiten myself' (that is, of My own Will allow Myself to be straitened 'under you')."[10]

(By the way, a *wain* is a farm wagon.)

What Barnes was saying here is that the word in Hebrew is "half active." God allows Himself to be straightened, like in Isaiah 43:24. God was saying literally, "I let Myself be wearied."[11]

When I think about that interpretation, I am blown away! God is not a helpless victim of love. He is not subject to our whims. He isn't manipulated by our behavior like an impotent marionette whose strings are pulled by a moody puppeteer. We do not wear God out. It is impossible. He does not grow weary by His very nature because He is all-powerful and self-existent. Yet He "allows" Himself to be wearied and feel the weight of our choices. God allows Himself to be bothered and burdened. The sheer kindness of that notion humbles me.

> **Pause here. Put down your pen and just ponder that. Take a moment to tell God how you feel about that attribute of His character.**

Now use Exodus 19:4, Deuteronomy 1:31, and Isaiah 46:3 to write a paragraph that expresses God's relationship with Israel. Write it in such a way that it reflects God's relationship with you personally.

Through God's words to Israel in Amos, I can hear Father God speaking to us, telling us that He loves us so much that He chooses to make us His willing burden. He lovingly bears with us. He bears our burdens. He carries us when we're weak, and through Christ, He carried the weight of our sin.

And even now He forbears. According to Romans 2:4, what is the reason God graciously forbears?

☐ So we will remember.

☐ So we will worship Him.

☐ So we will repent.

Forbearance refers to God's kindness in delaying rightful judgment. In Romans 2, Paul told us that we shouldn't take God's patience as an indication that God is disinterested or indulgent when it comes to our sin. God loved Israel so much that He was willing to forbear. He allowed Himself to be burdened by them. And He loves us so much that He allows Himself to bear with us and forbear our sin so that we will repent and come to Him.

Yet for Israel, they refused His kindness. It did not draw them to repentance. And He would no longer bear with them. Amos prophesied that judgment would be so significant that they would be brought to their knees.

READ THE FOLLOWING VERSES. Describe what the result of God's judgment would be.

Amos 2:14

Amos 2:15

Amos 2:16

Hard stuff. Israel, who was so secure, strong, and self-assured, learned that her own strength and natural ability would not cut it when judgment fell. Military strength or technology wouldn't be enough. Not even great courage could stand up against God's plan. And sadly, within forty years of Amos declaring this, Israel was taken into captivity by the Assyrians.

Oh, sister, Israel did not count the cost of her unfaithfulness. And, consequently, the Israelites paid for it.

Our sin weighs on God. He chooses to feel the weight of it, and we experience the wages of it (Rom. 6:23), yet we live the good life because Jesus received the wages of our sin for us. He bore our burden of sin all the way. He paid for it, and so may you and I pay Him the honor and loyalty He deserves.

Like ancient Israel, if we live unfaithfully, if we choose to stay in our sin, we will pay the cost. Without the blessing of God, "the swift isn't fast enough, the strong isn't strong enough, and the mighty isn't mighty enough to succeed."[12]

That ain't no good life for sure! So, my friend, let's live the good life of faithfulness through honoring God and rejecting sin. And all the sisters said, "Amen!"

Well done, my friend! You made it through the second invitation. Tomorrow will be our Good Life Day. We'll use it to help us live out what we've learned.

Love,

Jennifer

The good life gets even better when you share it with friends! Join Bible teacher Kelly Minter and me in an interview talking about what it looks like to live faithful. This is a bonus video streaming on the Lifeway On Demand app.

Day Five

YOUR GOOD LIFE DAY

Lord, I receive Your invitation to live faithful.

Which of these facets of the invitation to live faithful do I most need to accept in my life?

☐ Embrace God's Word.

☐ Treat others right.

☐ Remember God's goodness.

☐ Count the cost.

What would my life look like if I lived faithfully by embracing God's Word just one verse a day?

What is one practical way I can "treat others right"?

What choices can I make to remember His goodness on a daily basis?

This week, God taught me . . .

MY GOOD LIFE DECLARATION

To live the good life, I will live the God life and . . .

I will let go of:

I will trust God with:

I will take hold of:

To make your Good Life Day even better, listen to my #GoodLife playlist at jenniferrothschild.com/amos

Notes

To access the video teaching sessions, use the instructions in the back of your Bible study book.

INVITATION TWO:
Live Faithful

BEFORE THE VIDEO
Welcome and Prayer

VIDEO NOTES

Faithfulness: a "long _____ in the same direction."[13]

Faithfulness is not a feeling. It's _____.

FOUR FACTS ABOUT FAITHFULNESS:

1. When we are faithful to God's _____, we will be faithful to

 the _____.

2. When we are faithful to God's Word, we will experience _____.

 Three benefits of wonder/awe:

 1. _____.

 2. _____.

 3. _____.

3. Faithfulness has a _____.

4. _____ has a greater cost.

If you want to review what you just experienced, go to jenniferrothschild.com/amos to get a written summary of this video message.

CONVERSATION GUIDE

DAY ONE: How have you found yourself rejecting God's Word? Are there certain times, seasons, or situations when you are more prone to do this? Explain. What does it mean for you to embrace God's Word, and how does that change the trajectory of your sin spiral?

DAY TWO: How and why does physical prosperity become a sin trap for us? How has that happened in your life? How can you guard against that happening? What are some other weak areas of your life that the enemy exploits to lure you to sin? How have you experienced the strength, grace, and forgiveness of the Lord in these areas?

DAY THREE: How can intentional remembering of how God has worked in the past help shape how we live with hope in our present and future? Who are the people in your past that God used to steer you toward Him? What did they do and how did it make a difference in your faithfulness to the Lord?

DAY FOUR: When was a time God carried you through a difficult circumstance or season? How did He show you His faithful love and care? How was Jesus the ultimate burden bearer for us?

VIDEO: How would you explain the phrase, Faithfulness is a "long obedience in the same direction"?[14] How has faithfulness to the Lord been costly for you? How have you experienced joy in your faithfulness? What is something God taught you this week? Why is it so important that you accept God's invitation to live faithful?

INVITATION THREE

YOU ARE INVITED TO

Live Chosen

Day One

IT'S A FAMILY THING

To be loved but not known is comforting but superficial. To be known and not loved is our greatest fear. But to be fully known and truly loved is, well, a lot like being loved by God. It is what we need more than anything. It liberates us from pretense, humbles us out of our self-righteousness, and fortifies us for any difficulty life can throw at us.[1]

Tim Keller

————

Well, hey, you! As I'm typing this, it's a week before Father's Day, and I just had a fleeting thought that stopped my heart: *I wonder what I should get Dad for Father's Day? I need to get it in the mail soon.* Year after year I experience this feeling. I try to get the perfect gift or card for him and get it into the mail on time. But this time the thought didn't just stop my heart; it hurt my heart. I lost my dad several years ago just a week after filming the *Psalm 23* Bible Study. Yet he is still such a part of me that I sometimes forget he won't be on the other end of the phone when I tell Siri®, "Call Hero Dad." You've probably lost family too, so you know what I'm talking about, right? You never really get used to being apart.

With Dad fresh on my heart as I read Amos 3 today, I thought of something he often told me. Growing up in Miami, Florida, anytime I left for school or a party or a date or a trip, my dad would call out, "Remember who you are and whose you are." Now, of course, I belong to Christ, but what my dad was actually saying was: "Remember you are my girl. You are loved, and you can stand firm—and you better behave like it!" I had the blessing of growing up with a dad who loved and cared for me, yet I also knew that blessing came with a boatload of responsibility. My dad was my pastor. And if a bunch of us teenagers sat on the back pew smacking gum (*insert dissonant stabs of ominous organ chords here),* whispering, giggling, and passing notes during his sermon, I knew good and well that none of my naughty cohorts would get a talking-to from him. Only me. I would be held to a higher account because of who I was and whose I was. I was his daughter; I was called by his name.

NOW READ AMOS 3. How did Amos describe the people whom this word of the Lord spoke against in Amos 3:1-2?

The people of Israel are called *children, sons,* and *family* (*clan* in the CSB translation). Remember back in 930 BC, God's people had a bad spat and divided into two nations. Israel, the Northern Kingdom, was composed of ten tribes, and Judah, the Southern Kingdom, was composed of two tribes. But even though they were divided, all twelve tribes were still His whole family. They were called by His name. Just like I carried the privilege of my dad's name—and the responsibility that came with it—the Israelites bore God's name. They shouldered the responsibility to represent His name well. It was a family thing.

You and I have a lot in common with Israel and Judah. So let's do a quick reminder of who we are as family.

Lord, make Your Word a lamp to our feet and a light to our paths. We want to walk in Your truth. Amen. (See Ps. 119:105.)

We'll start down at the roots of this family tree. How does Deuteronomy 7:6-8 describe who Israel was to God?

Israel was chosen and loved by God. Nice status, huh? We share it.

LOOK AT 1 PETER 2:10. How did Peter describe who we were and who we are now?

We were: _____.

We are: _____.

We were once not a people, and now we are the people of God! Yes! Chosen woman, that is you!

OK, NOW READ GALATIANS 3:26-29. How did Paul describe you in these verses?

I am: _____.

You are God's daughter through faith in His Son, Jesus. You are clothed in Christ and are one in Christ. Since you belong to Jesus, you are now grafted into God's family, which started with Abraham (Gen. 12).

What adjectives would you use to describe how this truth makes you feel?

Knowing we are God's chosen and loved family changes the way we feel about ourselves and the way we live, or at least it should. Perhaps you need to pause here and ponder this. Feel free to stay here a bit and ask God to plant deeply in you what it means to be chosen and loved by Him. Journal your thoughts, with the date in the margin, so you will remember this truth.

DATE:

Yet, sister, not only are we loved and chosen by God, we are known by Him.

READ AMOS 3:2 in either the ESV, NASB, or NKJV translations using an online Bible resource.

How does that verse strike you? Israel was the only nation God "knew." What gives? God is all-knowing last I checked, right? The original Hebrew will help us out here. The same word for _know_ is also used in Genesis 4:1.[2]

Now Adam knew Eve his wife, and she conceived and bore Cain, saying, "I have gotten a man with the help of the LORD."

Genesis 4:1 (ESV)

When the Scripture says Adam "knew" Eve, was that an *information* kind of knowing or an *intimate* kind of knowing?

Well, sister, I will spare you the birds and bees. The word in Hebrew is *yada*, and in this context, it implies covenant, intimate knowing—so intimate that it produced children!

Back to Amos 3—God is omniscient, so, of course, He is not lacking in geographical skill. He knows all the nations. But here He is saying that of all the nations, Israel was His, the people He *yada*—knew intimately, chose, loved, and did life with. What a loving, beautiful God. Now, because of Christ, we are God's family. He *yadas* us. And not only does He know you, but He also loves you. That is the blessing of being His family—known intimately and loved completely.

What adjectives would you use to describe the security and value you experience because of this truth?

Gotta say, that kind of total knowing combined with complete love conjures up all sorts of humility in me. I think of Psalm 8:4a, "what is man that you are mindful of him?" (ESV).

PAUSE HERE AND PRAY PSALM 8:3-4. Spend a moment before your God and really consider who He is and that He is mindful of you.

When you consider His perfect knowledge and complete love, how can we say anything else but, "Who am I, Lord, that You are mindful of me?" This is what it means to be His family. Sometimes we just need to sit and consider.

There is something else about *yada* that you need to see. *Yada* has a Greek cousin, *ginosko*, and both words can suggest intimate knowledge.[3] You can find a form of *ginosko* in Philippians 3:10. Based on what you know of *yada*, what was Paul saying about knowing Jesus in Philippians 3:10?

Paul was seeking intimate knowledge rather than just settling for information, right? What about you? God *yada* you. Do you *ginosko* Him? I pray for you and me and all the Bible study buddies, that we truly *ginosko* God. There can be no good life without *ginosko*.

Just for fun, write the words *chosen, loved,* and *known* on several Post-it® notes, one word per note. Then stick them everywhere— kitchen table, computer screen, bathroom mirror— you get the idea! Let those words be affirmations of whose you are and who you are and reminders that prompt you to keep seeking to *ginosko* the God who loves you. Post a picture of your Post-it note prompts on your favorite social media platform with #AmosStudy so your Bible study buddies can be encouraged.

It is a family thing to be known by God, and it is a family thing to know God. Israel had plenty of understanding of who God is. The Israelites did not lack information about Him, but it seems they lacked the *ginosko* to stay loyal to Him.

I'll confess: I love learning and information! I'm constantly listening to a book and asking Google® a million questions. So, when it comes to Scripture and God Himself, I get a huge buzz from just getting some informational knowledge. But that means I need to be alert and not stop there—I need to have a Philippians 3:10 pursuit—to intimately know Jesus as Paul did, rather than settling for info like Israel did. Oh, my sister, don't forfeit the family blessing like Israel did by choosing information about God over intimacy with God.

The good life is the family life of blessing. It is a privilege to be called by His name. Yet, where there is blessing, there is responsibility. We bear His name, and our words, actions, and attitudes represent our Father. Just like Israel should have, we need to take our chosen, known, and loved family status seriously because God does. We'll deal with that more over the next few weeks.

So, let's take seriously who God is and who we are and live like His chosen family today!

Until tomorrow, my friend, "Let us know; let us press on to know the LORD (Hos. 6:3a, ESV).

Day Two

IT'S A MATTER OF WORDS

We do not need many words, but, rather, effective words.[4]

Seneca the Younger

You're here again, and I'm so glad. Way to be faithful, sister! In our study yesterday, we saw how God, through Amos, reminded the Israelites they were His family—chosen, loved, and known. And Amos made it clear that with that blessing came responsibility, right? So, let's dive right in!

> **TURN TO AMOS 3** and read the first two verses again.
>
> **Which of the following statements best represents God's response to Israel's disobedience (Amos 3:2)?**
>
> ☐ **God would permit Israel to keep misbehaving.**
>
> ☐ **God would passively ignore Israel's sin.**
>
> ☐ **God would punish Israel's sin.**
>
> ☐ **God would pick another people who aren't so naughty.**

Real love, God's love, isn't permissive or passive. He chose, loved, and knew Israel, but that intimate relationship didn't provide them a pass to sin or a permission slip to get out of judgment. The point Amos was about to make with some pretty crafty poetry is that punishment was inevitable because God is true to His Word. That is no surprise to you by now, my friend! We knew this was coming! So today, instead of focusing solely on the "what" of Amos's message, I want us to focus on the "how" of his presentation. We can learn a lot not just from what old Amos said, but from how he said it.

Before we keep reading Amos 3, pause, pour your coffee or a stout cup of tea, and then pray for God's Holy Spirit to guide you. That's what I just prayed as I sip some Starbucks® Verona® from my good life mug!

NOW READ AMOS 3:3-6. As you do, imagine you are standing in the crowd listening to Amos present this message. Jot down the rhetorical questions Amos posed and your intuitive response to each one.

Verse 3:

Verse 4:

Verse 5:

Verse 6:

If I were standing there next to you, I'd be shaking my head with every statement—*no, nope, nah, no,* and *no way!* And I may have been like, *Whew! That wasn't too bad.* But Amos's poetic questions may have not phased me much because I probably would not have understood where he was headed.

Amos was skillfully using a Hebrew rhetorical device that certainly would have kept the crowd tuned in. We started this study imagining Amos drawing a crowd in Israel as he condemned the surrounding nations in chapter 1. We figured that crowd must have been hanging on every word as Amos condemned Judah in chapter 2. But then, when he pointed to Israel, they probably got a little antsy and were about to walk away. However, Amos grabbed their attention with the flourish of a poetic prosecutor using that series of questions in Amos 3. Yet, until Amos 3:6, they may not have totally clued in.

What do the questions in Amos 3:6 suggest?

All along Amos showed certainty. No, you can't run in a three-legged race race unless you and your buddy are going the same way at the same pace. Well, that isn't exactly what Amos 3:3 said, but you get the idea. All those examples in verses 3-5 show that certain actions will have certain results. The conclusion in verse 6? The trumpet will blow, the people will tremble—God's judgment is certain.

You may be surprised to hear Amos, the country fig and sheep guy, presenting this fancy poetry. Why do you think God would lead Amos to present judgment through poetry instead of just plain legal argument?

Don't panic if you aren't sure! We don't really know, of course. But I wonder, *Could it have been because when we hear a poem full of word pictures, we tune in differently? Could it be that poetry inserts into our hearts what our heads can't contain?* Poetry is the language of love in many ways. Even when it expresses anger or lament, the emotion conveyed connects with our emotions.

It's possible something else is happening. Let me show you with an activity. Without looking at your notes or your Bible, write or draw some of the pictures Amos just presented in those verses in the boxes below.

I bet lions and fallen birds and friends walking together popped into your head and populated those boxes, right? Just like Amos's listeners, you got pulled into his poetry through the pictures he drew with his words.

Research proves we are hardwired for story. When you hear or see a story, your brain lights up like a city after dark. The neural activity in your brain increases up to fivefold when you get information from a story rather than just from presented facts.[5] People who study this stuff like to say, "Neurons that fire together wire together."[6] In other words, when your brain is so lit up by a story, you tend to take it in and remember the facts it represents much better.

Maybe this is why God, who *yada* Israel, was communicating through word pictures and poetry, the language of love rather than the dialect of legality.

Poetry too is a little incarnation, giving body to what had been before invisible and inaudible.[7]

C. S. LEWIS

Sister, God is our Father, and He speaks to His children in the way He knows we will understand. Amos used these poetic no-brainer statements to lead to the aha no-brainer.

If there is calamity in a city, will not the LORD have done it?
Amos 3:6 (NKJV)

And all the Israelites did the equivalent of, "Duh? Yes?" and the point was made.

It's wise to use language with specific intention to communicate to the family. Let me show you another example that isn't poetic but is just as effective.

READ 2 SAMUEL 12:1-6.

David totally bought into Nathan's story, didn't he? The story grabbed his heart and his imagination. That primed him for verse 7, which revealed what?

Think about it. If you really want to communicate effectively to a three-year-old who has a tendency to not tell the truth, you aren't likely to sit him down and begin a legal dissertation with "thou shalt not lie." Instead, you might scoop the little fibber into your arms and read him the story of Pinocchio as you tweak his little nose. And then, of course, you can follow it with a 2 Samuel 12:7 moment: "You are that toddler!" Ha!

The prophet Nathan masterfully used story to reveal King David's sin to him. Amos used the craft and beauty of poetry to speak the hard truth that God can and will judge. You and I have the privilege of being ambassadors of God's truth in this world. We not only need to hear and heed His truth for our lives, but we must be the truth storytellers for this world. After all, when God wanted to communicate who He is, He didn't do it through a digital download of facts. He sent the Word, Jesus, and He communicated to us through the greatest story ever told—the gospel.

So, sister, you are chosen, chosen to be a part of God's story, chosen to share God's story. As you finish up today's study, find some verses about how we use our words or use the ones I've listed below to craft a prayer asking God to help you use your words well for His story and His glory.

> **Psalm 19:14 • Proverbs 15:4 • Proverbs 15:23 • Proverbs 18:4
> Proverbs 25:11 • Ephesians 4:25 • 2 Timothy 2:23**

Dear God,

Amen.

If Amos can use words in a compelling way to communicate truth, so can you. Trust God to give you creativity and opportunity. He can use your words to invite others into the good life.

I'm cheering you on! See you tomorrow.

Day Three

THERE'S NOT MUCH PROFIT IN BEING A PROPHET!

He is no fool who gives what he cannot keep to gain what he cannot lose.[8]

Jim Elliot

———————

I hear it rumbling down my street. *Whoosh!* I love the windy grind of the pneumatic brakes on the yellow school bus. As I sit here at my desk with you and Amos, that sweet *whoosh*, along with the squeaks and groans of the wheels, fills my ears and imagination. Every time I hear those sounds I picture the bus door opening and children spilling out, including my little boys. I see them galloping down those metal stairs and into our front yard.

I remember one Wednesday when a yellow school bus brought little Connor home from kindergarten. He got off the bus carrying much more than a backpack full of pencil-scratched worksheets. He had picked up some heavy baggage in Mrs. Setzer's classroom at show-and-tell earlier that day—discouragement. Without even seeing his cute face, I knew that all was not well just by the sound of his voice.

I called out hopefully from the front porch, "Hey, Connor."

All I got in response was a series of sighs and dramatic moans, finally followed by an Eeyore®-like, "Hi, Mom."

"What's wrong?" I asked.

His small voice broke as he whimpered, "Nobody clapped."

The poor little guy had obviously tried not to cry the whole ride home.

"What do you mean?"

"At show-and-tell, nobody clapped for me." His few tears quickly gave way to indignation as he huffed, "They all clapped for Devin, but nobody clapped for me!"

With that pronouncement, he dropped his backpack and plopped down right there in our entryway—like he was organizing a six-year-old sit-in, a kindergarten passive resistance against all show-and-tell injustices. So, I joined him right there on the floor for our passive resistance sit-in. (It was my first ever, and my last sit-in, by the way.)

He explained the class had never clapped before during show-and-tell.

"Never, Mom, never ever. And I know because I was there—I pwomise."

But that day Connor was absolutely crushed that his classmates chose to applaud the display of Devin's picture.

"Well," I consoled, "I bet it's because Devin made the picture all by himself, and your classmates were trying to give him encouragement."

He pouted and sighed as he said, "I needed 'entouragement' too!"

Yeah, Connor, I get it. We all get it. We all need "entouragement."

And nobody needed it more than Amos!

I can only imagine how much Amos hoped for it, with the deep down thought, *Maybe they will listen. Maybe they'll respond this time. Maybe they'll even clap.* After all, he had just masterfully pulled them in with his rhetoric and logic. But nope.

Yesterday we left Amos standing in Bethel as he finished up his picturesque poem. And believe me—nobody clapped. Let's pick up with what he said next in Amos 3. Our focus will be verses 7-8.

As you begin, pause and pray. Ask God to show you His truth so you can walk in it. (See Ps. 86:11.)

 NOW READ AMOS 3:1-8 so you remember the context.

 Summarize what Amos said in verse 7.

 Hold that thought and now jot down what Paul said in Ephesians 3:5.

Amos stated that God doesn't act without revealing to His prophets. But Paul clearly said that God did act without revealing to all His prophets about His future plan to include Gentiles in the church.

What gives? Since the Bible does not contradict itself, how can both verses be true? Pause, ponder, and jot down your thoughts.

The answer lies in the context. Which of the following describes the context of Amos 3 so far?

☐ **Presenting a poetry slam**

☐ **Providing good clean entertainment**

☐ **Pronouncing judgment**

Amos 3 is all about pronouncing judgment, right? Amos was just one prophet in a long line of prophets who warned Israel of God's judgment. So when Amos said, "the Lord God does nothing unless He reveals . . ." (v. 7), he was referring to the fact that God wouldn't bring judgment without issuing a warning through His prophets first. What does that tell you about God?

It is a cruel parent who punishes a child without first revealing the rules, guidance, and warning. God had revealed, guided, and warned through His prophets who came before Amos. And at the very same time on the other side of town, the prophet Hosea was preaching and living the same message among the Israelites. God was generously warning the people He loved that He would do "nothing" without giving them a heads-up and chances to repent.

Through poetry, Amos warned the people and then told them in verse 8: *I am only the messenger; I can't help but speak this stuff.*

TURN BACK TO AMOS 1. How did God introduce Himself and His message?

Yep, the lion has roared. It was like Amos was saying, "Dude, when a lion roars, aren't you totally freaked out? Well, just as natural as it is for you to freak out when you hear a lion roar, it is just as natural for me to speak when God tells me to."

End of story. Tomorrow we will see in detail that instead of listening to Amos—following the logic and love of God's words—the Israelites persecuted Amos.

Girl, there is just not much profit in being a prophet! And the New Testament agrees.

READ THE FOLLOWING VERSES. Describe how each characterized what it was like to be a prophet.

Jesus in Matthew 5:12

Stephen in Acts 7:52

That was Jesus's and Stephen's bleak assessments looking back over history. But Jesus didn't predict it would be much better in the future. What did He say about sending prophets in Luke 11:49?

Yikes! Nobody clapped for sure!

It just doesn't go well for those faithful followers. Anytime God's prophets spoke God's truth, they paid a real cost. So, if you think you're having a bad day, let's get some perspective by looking at the big ways they felt the sting. Because, honestly, you may be able to relate.

What do 2 Kings 2:23, Jeremiah 20:7, and Luke 22:63-64 say prophets endure?

Tap into the feelings of being made fun of and answer this question: When have you felt that way in the past, and what did those feelings make you want to do?

Being taunted or made fun of makes me want to retreat or hide. Or if I'm feeling extra spunky, it makes me want to be twice as snarky and fight back. Prophets dealt with mocking and persecution just because they spoke truth. Sister, pay attention to that fact. If you're being ridiculed because of your faith or faithfulness, you are in good company. You may feel embarrassed or angry but chin up! Let them laugh.

READ 1 PETER 4:14 and celebrate the blessing of the good life.

READ ISAIAH 30:10, JEREMIAH 36:23, AND MICAH 2:6. What do these passages have in common?

Have you ever felt the sting of rejection? Describe what emotions rejection conjures in you and how you typically react.

I hate feeling rejected. It stirs up my insecurity and perfectionism and toxic competitiveness. Prophets felt all sorts of rejection and isolation because of their faithfulness to God and His message. Sister girl, if you feel the sting of rejection, you stay faithful because you are in the best company.

READ ISAIAH 53:3 and thank God for the privilege of identifying with Jesus.

What do 1 Kings 22:24, 2 Chronicles 24:21, and Jeremiah 20:2 highlight about the perils of being a prophet?

OK, that was rough. These guys were ridiculed, rejected, often physically abused, and even killed. Put simply, there was no profit in being a prophet. Except for the fact that each of those prophets was chosen by God and faithful to Him, and in that, there is ultimate profit.

Prophets lived assured of God's promises and presence. They lived faithful and chosen. They lived the God life so they lived the good life.

OBEDIENCE IS THE GOOD LIFE.

Often we feel there should be accolades or admiration when it comes to following God's call and walking in obedience. You know, our pastor should notice. We should have more likes on that deeply spiritual social media post. We should get a thank you note for helping, a commendation from the pulpit, an invitation to lead or teach, or whatever it is that is our gifting.

Oh, may we never glory in the flesh. May we find our greatest satisfaction in our faithful obedience rather than in an affirming response.

> **Where does this message meet you? Jot down your thoughts and feelings and end them with a prayer.**

As we finish, I'll take you back to the six-year-old sit-in.

"Connor," I soothed, "people aren't always going to clap even when we do something great. Sometimes people applaud for others and not for us. I know it feels good when we hear clapping, but when you don't hear people applaud, then it's easier to hear God's applause."

"God claps?"

"Well, sort of, I think He does."

I continued, "We can't hear God clapping with our ears, but we feel it in our hearts every time we love and obey Him."

I'm not sure my six-year-old show-and-tell resister really understood, but I did. I sure hope you do too, my sister. We may feel discouraged when we don't get the outcomes we'd hoped for. But "Our purpose is to please God, not people" (1 Thess. 2:4a, NLT).

So, my friend, keep living assured, chosen, and faithful and receive ultimate encouragement today from the applause of heaven even if nobody here on earth is clapping!

The LORD your God is in your midst, a victorious warrior. He will rejoice over you with joy, He will be quiet in His love, He will rejoice over you with shouts of joy.

Zephaniah 3:17

Day Four

FEEDBACK AND PUSHBACK

Be on your guard; stand firm in the faith; be courageous; be strong.

1 Corinthians 16:13 (NIV)

Girl, I'm living the good life doing this Bible study with you, for sure! You know though, there are often some "sandpaper people" who can make the good life feel not so good, right? I call them sandpaper people because they just rub you the wrong way! I'm sure you have or have had one or two in your life. Amos had one for sure. Today we get an up-close view in Amos 7 of his experience with a sandpaper person. This will help us know what to do when we feel the rub too!

Coffee poured. Heart open. Let's go!

Lord, may the seed of Your Word fall in the soft ground of our hearts. We want to receive in Jesus's name. Amen.

READ AMOS 7:10-11. Pretend you're a top-notch reporter for the Bethel online news service. Summarize verses 10 and 11 into a compelling, bold headline.

Here's mine:

AMAZIAH REVEALS TO KJ2 SHOCKING CONSPIRACY OF PROPHET FROM TEKOA

So, who was Amaziah anyway, and why was he so influential? First, let me tell you who he is not. If you do a word search in Scripture, you will find a King Amaziah in 2 Kings and 2 Chronicles. This is not our guy.

Our Amaziah was the chief priest of the temple at Bethel, the king's sanctuary. And he was a highly abrasive forty-grit sandpaper person for Amos!

SANDPAPER PEOPLE ACCUSE AND MISREPRESENT.

Based on Amos 7:10-12, what accusations did Amaziah bring against Amos?

Amaziah suggested Amos was disloyal to KJ2 (King Jeroboam II). *Hmm.* That kind of accusation is often one of the first made against someone who is being faithful to God. "She's not as dedicated to our denomination as she should be." "He didn't vote the way he should have." "She isn't supporting this movement." "He needs to stay in his lane!" Sometimes the misrepresentation is vague, just a hint or suggestion. Yet in this passage, Amaziah got specific. He told the king that according to Amos, the king's days were numbered and Israel was about to fall. And to prove this to KJ2, Amaziah likely quoted Amos to the king.

Imagine that the following verses are tweets that Amaziah screenshotted and pulled up on his phone to show the king.

READ AMOS 5:27. What is the big idea in this verse?

Prophet Amos ✅ •••

#Repent

FIND AMOS 6:1-7. Summarize Amos's message.

Prophet Amos ✅ •••

#IsraelDoomed

Yep, Amaziah was right—Amos did say it. Israel would go into exile. Amos also made it clear that the leaders would be among the first to be exiled. Yet on a closer read of Amos's prophecy, you won't find anywhere that Amos called out KJ2 specifically. A sandpaper person like Amaziah will often make an accusation and then confirm it with a clever misrepresentation of your words.

How did the sandpaper people do it to Jesus?

READ JOHN 2:19. THEN READ MARK 14:58.

Jesus wasn't talking about bringing in a literal wrecking ball and breaking down walls and demolishing the actual temple structure. No, in John 2:19, He was referring to Himself as the "temple" that would be destroyed and then raised to life. The Jewish leaders who wanted to marginalize and minimize Jesus took correct words and used them totally incorrectly to get what they wanted.

If you have a sandpaper person who is rubbing you raw with his/her false accusations or misrepresentations, sister, recognize you are not alone. You follow Amos, the burden bearer, and Jesus, our ultimate burden Bearer. Your identification with Christ can give you the strength to bear the burden of a sandpaper person's schemes. Jesus stands with you and stands up tall within you.

SANDPAPER PEOPLE QUESTION MOTIVES.

What did Amaziah say to Amos in Amos 7:12?

Yep, he told him to catch the next bus to Judah and get gone! What do you think that comment about eating bread ("earn your living" in the CSB translation) meant?

Amaziah was accusing Amos of having wrong motives. The implication is, "If you go home and preach this stuff, Judah will give you big love offerings." He was basically saying, "You just preach for money anyway, so go home and do it there."[9]

When someone is pulling an Amaziah on you, that person may not be able to misrepresent you or misuse what you've said for selfish purposes. So if impugning what is easy to see is not an option, your Amaziah needs to mess with what is unseen—your motives.

How does 1 Thessalonians 2:4 guide your thoughts and feelings if an Amaziah is questioning your motives?

My friend, you and I are called to please God, not people. Often, if you are truly pleasing God, you will displease the sandpaper people in your life. So don't worry if they question your motives. It is God alone who sees your motives, and He is the only One who matters.

SANDPAPER PEOPLE THREATEN HARM.

How could what Amaziah said in Amos 7:13 be perceived as a threat, especially in mentioning the king's sanctuary?

Can you feel the weight of that statement? "Sure, seer, if you want to stay right here in the king's sanctuary and speak against the king, be my guest." Amos was putting himself at risk to remain in Bethel after inciting the Israelites and upsetting Amaziah—who had sent word to the king about Amos.

If you've got an Amaziah, that person will rarely threaten to beat you up on the playground but may threaten harm in ways that could hurt much more—like destroying your reputation or misrepresenting your character.

If you were Amos, how would you feel? What would you want to do?

When we are misrepresented, accused, questioned, or threatened, we often feel fight or flight. Or in my case, just fright! But Amos gave us a great example of how to handle that kind of pushback from a sandpaper person.

WHAT FEEDBACK LOOKS LIKE

READ AMOS 7:14-17 and summarize the approach Amos took
with Amaziah.

Amaziah sarcastically said, "You're the seer." Amos said, "I'm just a shepherd." When Amos stated that he was not even "the son of a prophet" (v. 14), he was reminding Amaziah, who was a professional, that Amos was not a "career man"; he was a "called man."

God called Amos; Amos went. So Amos's feedback was underpinned with confidence that came from his calling, not his career. Amos didn't have to prove or bluster or convince. He just stated, *this is who I am*. Amaziah answered to KJ2, an earthly king. Amos answered to Lord Jehovah, the King of the universe. When you know ultimately to whom you answer, you can have the courage of Amos.

Sister, you do not have to prove or bluster either. Just be who God called you to be. Don't try to explain it, justify it, or be ashamed of it. Stand firm in your calling like Paul did when he made this statement in 1 Corinthians 15:10 (CSB):

But by the grace of God I am what I am, and his grace toward me was not in vain. On the contrary, I worked harder than any of them, yet not I, but the grace of God that was with me.

AMOS SAID THIS IS WHAT GOD SAYS.

Did you catch that contrast? Amaziah said, "This is what Amos says" (Amos 7:11). Amos said, "This is what God said" (v. 16, paraphrased). Amaziah was subtly discounting Amos's authority as a prophet by saying, "Amos says." Of course, Amaziah would do that. Because if Amos was speaking for God, then the whole power dynamic shifts. But if Amos was just a fig farmer and sheep breeder who was spouting his own opinions, then Amaziah could marginalize Amos and manipulate the situation.

But *boom*! Amos didn't push back with, "No, actually, let me explain." Rather, he started with what God said, not what Amos thought.

How can you apply the example of Amos when you get pushback from
a sandpaper person? How can you respond with the spirit of Amos?

Lord, may Your Word inform and influence each word we speak. Amen.

Dealing with sandpaper people is rough! Join me on my podcast, and I'll give you four healthy ways to deal with them. Listen anytime at *413podcast.com/23*.

4:13 Podcast, episode 23

Amos finished this narrative section (the only one in the book of Amos, by the way) with a drop-the-mic moment. He denounced the priest. Ironic, right? The priest who was trying to denounce Amos was denounced by Amos. A curse was spoken upon Amaziah, and it would also, sadly, affect his family (Amos 7:17).

Oh, my sister, you are invited to live chosen, but chosen doesn't mean you live without challenge. There will always be pushback from the enemy of your soul when you are living out your calling as God's daughter. Satan freaks out when you wake up because he knows you just complicated his day. He came to steal and kill, and sometimes he employs sandpaper people to help him steal your joy and kill your confidence.

But you, my friend, come into any conflict armed with an invitation from God to live assured, live faithful, and live chosen. When the enemy sends sandpaper people your way and they pull an Amaziah on you, remember who you are, remember whose you are, and let God's Word inform every word you speak.

That, my sister, is a wrap for Invitation Three. Tomorrow let's allow what we have learned to soak in and seep out! I hope you have a beautiful Good Life Day!

Love,

Jennifer

Day Five

YOUR GOOD LIFE DAY

Lord, I receive Your invitation to live chosen.

Which of these facets of the invitation to live chosen do I most need to accept in my life?

☐ Accept my chosen and loved identity.

☐ Seek intimacy with God over information about God.

☐ Use my words well to communicate God's story for His glory.

☐ Remain faithful under pressure.

☐ Handle conflict like Amos.

What would my life look like if I lived fully out of my chosen identity?

What is one practical way I can seek intimacy with God over information about Him?

This week, God taught me . . .

MY GOOD LIFE DECLARATION

To live the good life, I will live the God life and . . .

I will let go of:

I will trust God with:

I will take hold of:

To make your Good Life Day even better, listen to my #GoodLife playlist at jenniferrothschild.com/amos.

INVITATION THREE:
Live Chosen

BEFORE THE VIDEO
Welcome and Prayer

VIDEO NOTES

Our identity begins with _____.

You _____ your identity.

THREE TRUTHS ABOUT IDENTITY:

1. Identity impacts _____.

2. Your identity demands _____.

3. Your identity should initiate _____.

For our identity to be secure and grounded so that it initiates the proper action, we must

completely identify with _____.

Don't forget to go to jenniferrothschild.com/amos to get a written summary of the video message sent to your inbox.

CONVERSATION GUIDE

DAY ONE: How does knowing you are God's chosen and loved family affect the way you see God, yourself, and His purpose for you? On a scale of 1-10, with 1 being "I don't know God at all" and 10 being "I know God intimately," how would you rate your current relationship with Him? Why did you choose your score? What can you do to continually push that score higher?

DAY TWO: Why is it so important for us to understand that while God's love is deep and unconditional, it is not permissive or passive? How does that truth affect our daily walk with Him? How should it affect the way we view and relate to those around us who don't know Christ? Amos used his words skillfully to share the message God had for His people. Would you say you're doing the same? Explain. How can you better use your words to encourage believers and share the gospel with the lost?

DAY THREE: Have you ever been taunted, disrespected, or rejected because of your willingness to speak truth? Explain. How did that affect your faith? How did God use that experience in your life and witness? Is God currently asking you to take a step of faith and obedience that brings inherent risk? If not, take a moment and ask God to give you courage when that time comes. If so, how are you responding?

DAY FOUR: Do you have a sandpaper person in your life? If so, what is that person doing that is rubbing you raw? How are you dealing with that person? How does facing opposition often indicate you are walking in obedience? How does your identification with Christ give you strength to keep moving forward in joy and with purpose?

VIDEO: What's the difference in hoarding our identity versus stewarding it? How does knowing whose we are affect how we understand who we are? What is something God taught you this week? Why is it so important that you accept God's invitation to live chosen?

INVITATION FOUR

YOU ARE INVITED TO

Live Humble

Day One

HOW HUMILIATING!

Humility is not thinking less of yourself but thinking of yourself less.[1]

Rick Warren

My friend, we've made it to Invitation Four together! Yay us! I'm so happy we're digging in and accepting these invitations to the good life. And not only that, we're making Amos famous! So far, we've received God's gracious invitation through Amos to live assured, live faithful, and live chosen. And this week we are invited to live humble. The beautiful thing when we accept the invitation to live humble is that we are protected from all sorts of damaging, destructive, and depressing junk that could keep us from the good life.

Let's join Amos. Get something to drink. I've got my Bulletproof Coffee™ today. Settle in. Ask God to guide our study today. Amen.

Picture this: *It's late in the day, and Amos had been pleading with the Israelites. He felt the weight and urgency of this message of coming judgment, though Israel didn't seem to respond. So Amos flung his arms in the air and slowly began to turn to the north. Then he circled around east, then south, and all the while he called out to Egypt and Ashdod.* (See Amos 1:8 to refresh your memory about Ashdod.)

READ AMOS 3:9-10. Take a few notes on what Amos said.

Amos was likely standing in Samaria, located on the top of a hill above the surrounding valley. Yet Samaria was surrounded by even higher mountains. Imagine that those from Philistia (Ashdod) and Egypt were up on those mountains, with high-powered binoculars, looking down into Samaria's streets as if they had been given the best seats in an amphitheater. Amos was inviting them to bear witness to Israel's sin, Israel's oppressive ways. Through this rhetorical device, Amos was calling the palaces of Israel's enemies to serve as witnesses against Israel.

We find similar language in a snippet of Amos's sermon in Amos 6. Check out verse 1. To whom was Amos addressing these remarks?

To whom was he calling Israel to compare themselves (Amos 6:1-3)?

Amos called out the big dogs, or shall I say, "lazy big dogs," of Israel and Judah (Zion) and made them compare themselves to some of their pagan neighbors. The result? They were no better.

Based on what you know about Israel during this time, circle how you think God's words through Amos made them feel.

IRRITATED	INSULTED	HUMILIATED
ENRAGED	DEMEANED	RESENTFUL

Trick question! Probably all of the above! Philistia and Egypt had reputations for being especially brutal and unjust. So the Israelites felt they were morally superior to them and other pagan nations. They had to be super humiliated that God, through Amos, would invite Israel's enemies to be legitimate witnesses to Israel's sin.

But, sister, this should be no surprise, right? A humble person can't be humiliated.

Let's pause and examine why Israel would have felt humiliated. What do the following verses teach us about pride and humility?

2 Chronicles 7:14

Proverbs 3:34

Proverbs 16:18

Isaiah 2:17

Luke 1:52

James 4:6-10

When we live humble, we get grace and the nearness of God as a result. We experience favor and are sheltered from the ugliness arrogance brings. Yet pride inevitably creeps back in and sets us up for a flat-on-our-face moment! The more elevated we are in our own minds, the harder and more embarrassing the fall is.

God opposes the proud. Pride destroys and injures and separates. It's a bad deal. But if we do humble ourselves, God hears, forgives, and heals. Oh, Israel, why didn't you choose humility? Oh, sister, do we choose humility?

Before you answer that, let me take you back to my early twenties.

I had an awkward encounter with the boy I was dating. The euphoria of our early crush was giving way to the reality of our incompatibility. To put it mildly, it was a square peg in a round hole kind of thing. But he was so cute that it took me weeks to notice. It became really obvious, though, on one warm spring afternoon as we walked through the park. Evidently, Boyfriend had something—a few things—on his mind. He showed me to a concrete bench and sat me down. He cleared his throat and began—with great detail—to point out some things in my life that he thought needed improvement. Girl, we were there for thirty minutes. He had a *long* list! Now, he probably was right. I don't recall what my defects were, but, sister, what I do remember was his response to my question in that conversation. I asked him if he really thought he was acting in humility. Let's just say, he did not like that one bit! He jumped off that bench like it was a hot stove! He stood over me and with full confidence, with hands on hips, said emphatically, "I think I am very humble." *Boom!* Conversation ended. And the relationship ended the very next day!

I tell you that story before we answer the question about whether or not we are choosing humility, because, sister, if we're confident that we are humble, we may not be!

THERE IS NO GOOD LIFE WITHOUT HUMILITY.

Humility is one of those fuzzy things. Truly, the humble person rarely thinks she is humble, and often the person who is not humble thinks she is. Ponder the following questions to uncover if you have accepted God's invitation to live humble.

Do I feel I am indispensable?

Are my ideas, my plans, my ways usually best?

Do I insist on having the last word in a conversation or disagreement?

Do I tend to see life as us versus them?

Do I listen to or consider the ideas of those I disagree with?

Am I quick to insert my opinion into each situation or conversation?

Do I use anger, bitterness, or feeling offended as fuel to speak truth?

Do I keep a running list of how someone could do better?

If you thought about somebody else while you read those questions, or if you answered yes on most of them, chances are you have not yet accepted God's invitation to live humble. Or maybe you did, but life happened and pride wiggled its way into your heart. I get it. I've got a stubborn streak and a strong will, so if I stray from God's Word, I end up falling into pride's toxic, deceitful pit. Trust me when I say you can let that pride go and humble yourself before God. Humility invites the grace and nearness of God you long for.

Pause right now and talk to God about this. Journal your thoughts or prayer below so you can look back on this marker in your life.

OK, now I want you to see something interesting in Amos 3:10. It's an often-overlooked result of a lack of humility.

> **What do you think the Scripture means by, "[Israel does] not know how to do what is right"?**

Interesting. It's not that the Israelites didn't know what was right or wrong; it's that they no longer knew that right and wrong even existed or mattered. All they knew was relativity.

When we pridefully step out from under God's authority, the result is chaos and disorder. This is another reason why humility matters. Pride deceives us into thinking that our way is the way, and our truth is the truth. Oh, Lord, teach us true humility.

> **NOW READ AMOS 3:11-12.** This is what could have been avoided if the Israelites had humbled themselves.
>
> **Who was the adversary Amos was talking about? (Read 1 Chron. 5:26 for a hint.)**
>
> **What would this enemy do? (Read 2 Kings 17:5-6 for a hint.)**

About forty years after Amos spoke these words, the Assyrians plundered Israel and took most of the Israelites into exile. Israel's strength was sapped and her palaces were plundered. As Amos said, the Israelites lost everything because they held on to pride.

> **In true Amos fashion, he described the awful outcome with a picturesque finish in Amos 3:12. What adjectives would you use to describe the image Amos painted of Israel's exile?**

Violent? Merciless? Dinner? (Kidding!) Those are just a few words that come to mind when I read that graphic picture of a lamb in a lion's jaws. As a shepherd, Amos was familiar with the practice of a shepherd gathering the remains of a sheep devoured by a wild animal as proof to the owner that the sheep was killed, not stolen.

The shepherd Amos drew a picture for the Israelites to show how they would be pulled to pieces and scattered, and the small remains, like pieces of broken furniture, would serve as proof of the nation's death. In approximately 740 BC, this horrible prediction began coming true under the Assyrian King Pul (more commonly known as Tiglath-Pileser III).[2] Then, about twenty years later, in approximately 722 BC, Samaria was totally conquered by Assyrian King Shalmaneser V.[3] The wealth and possessions which represented Israel's prosperity lay in shattered, scattered pieces—like the Israelites' pride.

God's intention for His chosen people was not to be torn and scattered like the remains of a devoured lamb. The Lord was their Shepherd. He intended to draw them to Himself, lead them beside still waters, and guide them down the path of righteousness for His name's sake (Ps. 23). But like a stubborn cow (Hos. 4:16), Israel chose pride over humility, and the result was humiliation and destruction.

May we be humble sheep, humbly following our Shepherd. And all the sisters said, "Amen!"

Good stuff. See you tomorrow, my friend.

Day Two

HUSBAND, BRING ME A DRINK!

The natural life in each of us is something self-centered, something that wants to be petted and admired, to take advantage of other lives, to exploit the whole universe.[4]

C. S. Lewis

I've been looking forward to us getting to this part of Amos for a while because it's so wacky and wise. Let's get right to it.

READ AMOS 4:1-3.

I don't know if you're laughing, scratching your head, or starting to get mad, but I promise you will enjoy what you learn today. Take a deep breath and pray Psalm 25:5.

Guide me in Your truth and teach me, for You are God my Savior, and my hope is in You all day long. Amen.

Now to the elephant in the room, or shall I say, now to the cow in the Bible study.

> **Let's determine who these "cows of Bashan" were. I'll provide you with some context in a moment, but if you feel ambitious, check your favorite Bible resource or just Google "Bashan" to discover Amos's context for yourself.**

> **Bashan was:**

Bashan is mentioned over fifty times in Scripture. It was located east of the Jordan in the northern part of Israel. Today it's called the Golan Heights. Back in the day, Bashan was famous for producing fat and healthy livestock on its fertile, lush land.

> **With that in mind, what was Amos calling these certain women in Israel?**

Did you have the nerve to write that? I may as well write it out: *fat cows*. Yes. Have you ever in your whole life done a Bible study where you spent one entire day talking about fat cows? Me neither. And that, my sister, is why I am still drinking Bulletproof Coffee today! *Gulp*.

It is incredibly insulting for a woman to be called a fat cow in our culture, right? Yet we can't look at Amos through our cultural lens because we will totally misunderstand and miss out on this interesting truth. Let's look at it through an eighth century BC Middle Eastern lens.

First, why call them cows?

> **LOOK AT SONG OF SOLOMON 1:9 AND 2:9** to see what the lovers called each other. How does the use of animal imagery in Song of Solomon inform your understanding of Amos's use of "cows" here?

> Girl, it was what they knew, so it was what they used. Also, how does Amos's background inform your understanding of his use of animal imagery?

We've already looked at Amos 7:14 where he made it clear that he was not a prophet or a son of a prophet. He was a sheep herder. So it's perfectly legit that he would pull from his world to communicate this word. Also, comparing a woman to an animal did not offend anyone in the ancient world, so don't let it rock your world either.

In the Hebrew, "the word translated 'cows' is a feminine noun . . . and the verb forms and pronouns . . . are all feminine plural" too.[5] So Amos was definitely addressing the ladies. Yet his words weren't directed to all women in Israel, just certain ones—the wealthy women who carried a little extra weight.

In the ancient world, being a little chubby was actually considered attractive and enviable. If you were on the plump side, it meant you had wealth, were healthy, and likely could bear healthy babies. In many ways, it was a status symbol. I know, I know—how did we get this so wrong in our present world? *Wink*.

Think about it. If it wasn't an insult for Amos to call these women "fat cows," what character flaws could he have been calling out in Amos 4:1? Could it be that Amos was calling them out for apathy, selfishness, or laziness?

Hmm. If he was calling them out for apathy, selfishness, or laziness, what do you see in Amos 4:1 and Amos 6:4-6 that confirms that?

Amos point-blank said they overlooked and even oppressed the helpless and poor. That sure sounds like apathy and selfishness to me. Some say they were doing this indirectly by badgering their husbands to satisfy their needs. The husbands caved to their demands by plundering the less fortunate.[6] Amos painted a marvelous word picture of these spoiled bovines lounging on their couches, rings on their fingers, noses in the air, feet on silk cushions, calling out, "Oh, husband, bring me an extra hot almond milk latte, no foam. And get a *mooooooove* on it!" (Sorry, I couldn't resist the cow humor.)

So maybe what Amos was really saying was "lazy cows." Or "selfish cows." Those definitely qualify as insults in my book!

The Israelites, including these Bashan Babes, knew what God expected. God had given Israel the Law, and it did not include, "Be ye lazy" and "Be ye selfish." God's standard was captured in the wisdom of Solomon, which they knew well.

Jot beside each reference what these women would have known.

PROVERBS 3:27	
PROVERBS 12:24	
PROVERBS 19:17	
PROVERBS 21:13	
PROVERBS 22:9	
PROVERBS 29:7	

Oh, sister, when I read through those proverbs, I shudder to think those women blatantly ignored what God esteemed. They knew a woman of virtue opened her arms to the poor rather than oppressed the poor (Prov. 31:20). These women could have used their wealth and influence to lift up the helpless, but they chose apathy over empathy, selfishness over sacrifice. Their character didn't reflect the heart of God.

Pause here for a sec and let me be super clear about two things before we go on. First, there is not one thing wrong with having wealth or a high position in society. Amos wasn't condemning these women because of their bank accounts. He was condemning them for their character and heart.

Secondly, do not hear any of this as a slam on women. Though Amos 4:1-4 was written about women, they represent what both genders are called to. Men don't get a pass on virtue or empathy just because they aren't mentioned here. We are all called to humility and holiness.

> **What did God say would happen to these women (and their passive husbands) in Amos 4:2-3? If Amos was continuing his word picture of cows, what images do these verses conjure?**

Reminds me of a butcher shop. Awful, isn't it? It just doesn't end well for a fat cow and her herd.

> **READ AMOS 6:7-11 to see this picture from another angle.**

In these verses, Amos was prophesying Israel's destruction and exile. The words are so graphic. And sadly, it happened. The Israelite hearers probably recognized what Amos was describing. They knew that when a nation was conquered, the victors would often tie the people together with a series of ropes or string and fishhooks pierced through their lower lips or noses.[7] They would have been marched out through the broken walls of their city in pain, despair, and humiliation.

There is just nothing good about this, is there? These women could have chosen humility, and it would have changed their futures.

> **That prompts a question. What areas of your life do you need to choose humility to change your future? Pause here, put down your pen, and ponder that question. Ask God in what areas of your life you need to choose humility.**

Pride never ends well. It lulls us into a self-centered, self-gratifying mindset that leaves no room for others. It invites apathy that morphs into entitlement and indulgence that is never satisfied. And once it gets its hooks in us, it drags us into a painful trap of despair, and then it leaves us alone and humiliated.

The cows of Bashan and the rest of their elite herd were full of themselves and, consequently, they had no room for anything or anyone else. Humility would have emptied them of pride and made room for repentance and hope. The same applies to you and me, sister.

SELFISHNESS IS NOT THE GOOD LIFE.

Just like those whom Amos called the "cows of Bashan," without humility and holiness, we can become indulgent, entitled, and consider ourselves elite.

Henry Wadsworth Longfellow wrote that sometimes we "may learn more from a man's errors, than from his virtues."[8] May we learn from these ancient sisters' errors and may those mistakes prompt us to choose humility.

OK, interesting, sobering stuff today. Now it's time to *moooooooove* on! Sorry. That's the last of my cow humor, promise.

See you tomorrow!

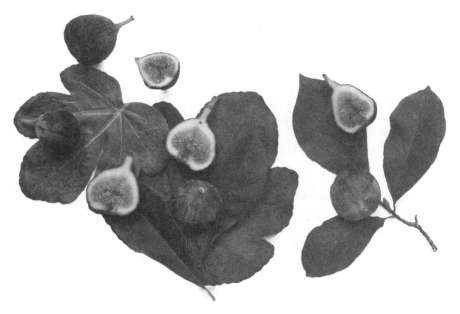

Day Three

IT'S NOT ALL ABOUT ME

The world's smallest package is a person wrapped up in themselves.[9]

Lecrae

———

Hey, sister! I was telling my husband, Phil, about the cows from yesterday as we were getting coffee this morning. So I sat down at the kitchen table, waved my hand, lifted my chin, and quoted Amos 4:1: "Husband, bring us some drinks!" He had no idea what I was doing, but I couldn't stop laughing. "Phil, it's biblical," I said. OK, so that was a perfect example of using Scripture out of context, but it got me coffee! You should try it! Once I explained it to him, all he said was, "Well, I guess you need to *milk* that for all it's worth." Wah, wah. Oh, brother.

All right, back to today. So far Amos has given us a clear picture of why humility is always the best choice, right? Yet today we're going to see a sneaky way our lack of humility shows up. Our pride or selfishness can be cloaked in beautiful spiritual rituals.

> **PAUSE RIGHT HERE AND READ AMOS 4:4-5** to see how easy it is to make everything—including worship—all about us.

Lord, center our hearts on You and Your truth today. In Jesus's name, amen.

> **Let's make clear what Amos was saying so we can understand the meaning of this passage. What are the four sarcastic "to-dos" Amos mentioned in Amos 4:4?**

First, he called out two geographical locations—Bethel and Gilgal. Gilgal held a special place in Israel's history. It was the first spot the Israelites set up camp when they entered the promised land (Josh. 4:19-20). And there they made a statement, through circumcision and celebrating the Passover, that once again they were a people devoted to God (Josh. 5:2-12). But somewhere along the way, they left that devotion behind, and Gilgal became a place of false worship (Hos. 12:11).[10]

Bethel, which we've talked about before, also held a significant place in Israel's history, going all the way back to the time of Abraham (Gen. 13:3). In Amos's day, it was better known as the king's sanctuary and was a national place of worship. It was one of two places where King Jeroboam built a temple after Israel's civil war. (The other temple was located in Dan [1 Kings 12:25-30].) When the kingdom split, King Rehoboam reigned over Judah in the south and kept temple worship of the one true God, Yahweh, in Jerusalem. Consequently, Levites in the Northern Kingdom got kicked out or chose to leave Bethel for Judah. That left priests like Amaziah, who led the people in empty worship of shiny goats and calf idols.

TAKE A MINUTE TO READ THIS FASCINATING HISTORY IN 2 CHRONICLES 11.

As far as the Israelites were concerned, they went to Bethel and Gilgal to worship and sacrifice to God. But Amos set them straight on what was really taking place.

> **USE YOUR FAVORITE BIBLE RESOURCE TO READ DIFFERENT TRANSLATIONS OF AMOS 4:4. Jot down the words Amos used to describe what the Israelites were actually doing at the temples.**

They were doing wrong and multiplying wrongdoing. They were transgressing, rebelling, sinning, and sinning yet more.

But what gives? In their minds, they were following the Law and bringing sacrifices. Look at what you wrote for numbers three and four on your previous list. Morning sacrifices. Tithes every three days. Sounds spiritual.

> **Add to your list by jotting down what else Amos 4:5 described the Israelites were doing.**

They were offering thanksgiving offerings and even giving voluntary offerings. Sounds like they were worshiping, doesn't it?

> **Yet what does Deuteronomy 14:28 suggest about their every-three-days tithe?**

Every three years? Amos was using sarcasm this whole time and saying, "Look, people, even if you gave this every-three-year tithe every three days, it's empty because it's tainted and showy." The condition of their hearts made this religious expression still wrong, sinful, and rebellious.

And then there's the "sacrifice of thanksgiving with leaven" (NKJV). You can read Leviticus 7:12-13 to see where this started. The point Amos was likely making was that only one offering was supposed to include leaven—the wave offering offered once a year. If so, he was suggesting that their sacrifices were "polluted by leaven," just like their worship in general was polluted by sin.[11]

OK, so we get the ugly picture. What they called worship, God called wrong, sin, and transgression. But the real kicker to me is what Amos said next. It wasn't just "what" they were doing, but "how" they felt about it.

Which of the following phrases best describes how they felt about their worship at the end of Amos 4:5?

☐ **They were satisfied with their worship.**

☐ **They tolerated their worship.**

☐ **They loved to boast about their worship.**

Loved. That's such a strong, emotional word, isn't it? The original Hebrew word translated as *loved* is *'āhab*.[12] It's the same word used in Deuteronomy 6:5, where it says "You shall love the LORD your God with all your heart . . ." It carries the feeling of longing for or breathing after another.13

PAUSE AND READ DEUTERONOMY 6:5. Jot down how the word '*āhab* showing up in both of these passages affects how you feel about what they were doing.

Deuteronomy 6:4-5 is called the Shema, which became a daily prayer and revered confession of faith in Jewish tradition. The term *Shema* is the Hebrew word for *listen*, which is the first word in verse 4.

It breaks my heart—such deep emotion and affection that belonged to God were what fueled the Israelites' superficial, self-gratifying, self-promoting spiritual activity. They were into their ritual, and they didn't mind sharing all that "love" with fake gods. And they loved to crow about it.

> **READ AMOS 4:5 in the NIV translation and jot down the two words used to describe how they talked about their worship.**
>
> They _____ and _____.

The Israelites bragged and boasted about their worship. *Hmm.* Sound familiar? Remind you of anyone in the New Testament?

> **READ MATHEW 23:25-28. If you were explaining this passage to a brand-new Christian or a young child, how would you summarize the point Jesus made?**

It troubles me to think that, like the Pharisees, the Israelites could have become so detached from and numb to the one true God and so attached to their own empty routines of worship. When they had that kind of love for their religious reputations, and such deep affection for the idols of Bethel and Gilgal, they were breaking the command of the Shema and the heart of God.

You know, sister, like those ancient Israelites and Pharisees, we can show up in God's presence and go through the worship motions yet not feel one emotion. We can raise hands and still keep a hard heart. We can bow our heads and maintain a stiff neck. We can do all the right things with a totally wrong heart.

We can love it—love the music, love the atmosphere, love how we feel, love how we look to others, love the experience, yet not "love" God through it. We can worship the worship experience more than we worship God through the worship experience. When we have fallen into a self-centered worship mode, bragging and boasting about our religious activity seems to follow. We can easily slip into a Pharisee mode of loving how our worship makes us feel rather than simply loving and adoring God.

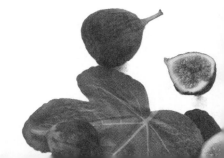

May it never be. Worship is not a product to evaluate; it is a privilege to participate in.

The good life is not about us; it's about God. When He is the center, the focus, we live the God life, and that is the best life ever. Humility turns the focus from ourselves and makes everything about God.

So, sister to sister, guard against the modern temptation to evaluate the worship style, the worship pastor, or the worship team on your way home from church. Be one who loves the God you worship so much that even if you don't love the style of worship, you are more focused on the subject and substance of your worship. It is not about us. But when we make it so, we are least happy, God is not honored, and our worship gets polluted.

You don't want that, and neither do I. So let's make a prayer declaration to affirm our desire to be pure, God-centered worshipers.

> **Reference or rephrase the following verses to create a prayer of affirmation and desire to love God only and always as you worship Him with purity: Psalm 24:3-5; 51:10; Matthew 5:8; 22:37; Hebrews 10:22; James 4:8.**

My mouth will speak in praise of the LORD. Let every creature praise his holy name for ever and ever.
Psalm 145:21 (NIV)

So may we live humble, my sister, for the glory of God. Amen and amen!

Now, let's go live what we've learned.

Day Four

IT DIDN'T HAVE TO BE THIS WAY

It was pride that changed angels into devils; it is humility that makes men as angels.[14]

Saint Augustine

We're near the end of this week's study, so I thought we'd leave eighth-century Israel and Amos for a few paragraphs and travel to 1767 France. There we'll meet a composer, Johann Schobert. But if he invites you to dinner, say no. Here's why.

It was a sunny Parisian day in Le pré-Saint-Gervais when a happy Johann set out mushroom picking with his family. Birds fluttered and chirped, a breeze rustled the leaves in the trees, and the fragrance of wet earth filled the air. There was no shortage of mushrooms that day.

Johann had built up quite an appetite by the time he returned with his family and a basket brimming with those smokey, woodsy delicacies. But Schobert was a composer, not a chef. What was he supposed to do—pull out a skillet to make dinner? Schobert would leave it to the professionals.

So he took his treasured fungi to a local chef and asked him to prepare them. The chef scowled, shook his head, and replied with the French equivalent of, "No way, Johann!"

The chef told him that the mushrooms were poisonous.

But that didn't deter the mushroom-loving Schobert. After all, that was just one chef's opinion. So he scooped up his mushrooms and found another chef in another restaurant in Bois de Boulogne. Johann unveiled his culinary find to the second chef and asked him to prepare the mushrooms for him. Again, he got the French equivalent of, "No way, Johann!"

The second chef told him the mushrooms were poisonous.

Schobert wanted his mushrooms, though. He didn't even entertain the possibility that those chefs could be right. He found a doctor acquaintance and asked the good doctor if he thought the mushrooms would be OK to eat. The doctor shrugged and offered the French equivalent of, "Sure, Schobert, help yourself."

A vindicated Schobert nodded curtly and carried his bounty home and into the kitchen. Within hours, a fragrant soup was simmering. The table was set and Schobert had to feel so satisfied he was getting his mushrooms his way. He invited his doctor friend to have dinner with his family, and they all enjoyed their soup.

Schobert, his wife, all but one of their children, and his doctor friend died.[15]

So here I sit at my desk sipping coffee, wanting to shout back through the centuries to Schobert, "Dude, would it have killed you to admit you were wrong?" And I hear my answer reverberate in my heart, "No, it would have saved you to admit you were wrong."

I want to hear those words clearly in my own soul. "Jennifer, it can save you to admit you are wrong." It could have saved the Israelites in Amos's day too.

When we don't accept the invitation to live humble, we invite the ruin pride brings.

My friend, let's flip back to Amos 3 to see a vivid picture of the consequences of pride. (Don't worry. If you're keeping track, we will finish up Amos 4 later.)

Lord, open our hearts to Your Word. May it be the delight of our souls. Amen.

> **READ AMOS 3:13-15. As you do, sketch little images of what you read. These verses are full of drawable objects.**

I bet you sketched a bit of real estate, huh, Picasso?

Prosperous Israel had some big houses—summer houses and winter houses—back in the day.

Archaeologists found that prior to King Jeroboam II, cities in Israel had homes that were all about the same size. But when archaeologists studied homes from around the time when Amos was preaching, they found a change. Commentator David Guzik wrote, "starting in the eighth century B.C. — ancient cities like Tirzah have a neighborhood of large, expensive houses and another neighborhood of small, crowded structures, smaller than the houses from previous years. The larger houses are filled with the marks of prosperity, and the oppressive rich of Israel thought they could find safety there — but God's judgment came against those houses as well, just as Amos promised."[16]

Before we deal more with the Israelites' homes, let's start with the temple. Look again at Amos 3:14. Why was the temple a target of God's judgment?

As you well know by now, Bethel was the temple where the golden calf shone brightly. God was saying, "Enough idolatry. Destroyed."

Did you catch the "horns of the altar" phrase?

READ 1 KINGS 1:50-53. Based on those verses, what else was God implying about the destruction of the temple?

Some scholars believe this promise that the horns of the altar will fall meant that there would be no more place of asylum, no safe place for Israel. There would be no way to escape the coming judgment.[17] Bleak, isn't it?

NOW LOOK BACK AT AMOS 3:15 AGAIN. Do you think God was judging the Israelites because of the size and number of their homes? Is it wrong to have a big house or more than one house? Jot down your thoughts.

The condemnation wasn't about the homes themselves; it was what the homes represented. Sister, it is always about our hearts.

Read the following verses in Amos and Hosea. What do they tell you about the heart of the people who were making the real estate choices?

Hosea 12:5-8

Amos 2:6-7

Amos 5:10-12

Amos 8:6

Those grand homes were built with more than wood and stone. They were built from the exploitation of the poor, oppression, and downright apathetic selfishness. They were brick and mortar representations of Israel's pride and injustice. God made it clear that pride came before destruction, and this passage in Amos 3 is such a vivid affirmation of that truth.

But again, Amos was not making this about houses, but about hearts—our hearts. Pure hearts can earn big paychecks and a minimum wage worker can have a haughty spirit. Pride can wear rags, and humility can dwell in a mansion.

But the truth is that pride breaks things. Pride promotes itself as an ally to the insecure, but it crumbles fast. It brings its own destruction. Pride breaks apart families. It destroys relationships. It separates us from God. It fractures reputations and crushes potential. Pride doesn't protect us, it betrays us. So why in the world would we hold on to it and build our lives on it?

One of the essential parts of the good life is admitting you are wrong. You've been wrong; I've been wrong. While pride demands you admit no wrong, humility admits error, mistakes, shortcomings, sin. Pride is a poisonous mushroom stew that you think will nourish you, but it actually annihilates you.

So, pride be gone! May we proceed on our knees in humility together.

As you finish up today, get gut honest with yourself and God. Has God shown you pride in your life you need to turn from and walk in humility instead? Oh, girl, don't be ashamed. Pride shows up in my life all the time, and I have to constantly repent.

The good life gets even better when you share it with friends! Join me and singer-songwriter Nicole C. Mullen as we talk about what it means to live humble and justly. This is a bonus video streaming on the Lifeway On Demand app.

Use Psalm 32:5 below to guide your thoughts and prayers. Consider writing a prayer of confession. If you don't want to write it, put down your pen and pray right here and right now, personalizing each phrase of the verse.

I acknowledged my sin to you, and I did not cover my iniquity; I said, "I will confess my transgressions to the LORD," and you forgave the iniquity of my sin. Selah.
Psalm 32:5 (ESV)

Oh, my sister, it won't kill you to admit you are wrong, but it may destroy what matters most to you to remain wrong. So live humble.

Amos told Israel her ways would bring her destruction. But instead of the Israelites listening to what they didn't want to hear and admitting they could be wrong, they dug in their heels and let pride dig their own graves. Like Schobert and the deadly mushroom stew, it killed them to not admit they were wrong. If they had only humbled themselves, things may have turned out differently.

Well, my sister, look at you. You made it through another invitation of study! You are making Amos famous. Enjoy your Good Life Day tomorrow!

Love,

Jennifer

Day Five

YOUR GOOD LIFE DAY

Lord, I receive Your invitation to live humble.

Where did the message meet me this week?

☐ I desire greater humility in my relationships.

☐ I want to have a greater awareness of pride in my life.

☐ I want to be more mindful of how I treat others.

☐ I accepted God's invitation to live humble, and I am trusting Him to help me.

What would my life look like if I lived out of humility instead of pride?

What is one practical way I can seek humility?

How can I practically show empathy over apathy?

What is one area of my life I can choose sacrifice over selfishness?

This week, God taught me . . .

MY GOOD LIFE DECLARATION

To live the good life, I will live the God life and . . .

I will let go of:

I will trust God with:

I will take hold of:

To make your Good Life Day even better, listen to my #GoodLife playlist at jenniferrothschild.com/amos.

INVITATION FOUR:
Live Humble

BEFORE THE VIDEO
Welcome and Prayer

To access the video teaching sessions, use the instructions in the back of your Bible study book.

VIDEO NOTES

Humility is not just an attribute, not just an attitude. It is an _____.

QUALITIES OF A HUMBLE WOMAN:

1. A humble woman has a right _____ of herself.

 "Humility is not thinking less of yourself; it is thinking of

 yourself _____."[18]

2. A humble woman has a right _____ of her _____.

 To be contrite means you have remorse over your sin, which leads

 to _____, which results in restored _____.

3. A humble woman has a right _____ for _____ _____.

Would you like to read my written summary of this video teaching? Just go to jenniferrothschild.com/amos to get a summary emailed to you.

CONVERSATION GUIDE

DAY ONE: Why is pride such a hindrance to our faithful walk with Christ and our service to Him? How have you seen pride negatively affect your spiritual life? What would you say are the qualities of a humble person? Which of these qualities are most difficult for you to embody? What needs to happen for you to walk in humility more consistently?

DAY TWO: How do you see the damaging attitudes of apathy and entitlement in our culture? How do you see these things present in your life? What effect are they having in your faith walk? What are some specific things you can do or choices you need to make to live selflessly rather than selfishly?

DAY THREE: Spiritual rituals and traditions are not all bad, but what could be the danger of continuing to do the same thing over and over? Have you ever seen those negative effects in the life of a church you were attending? What are some possible warning signs that you're just going through the motions in your spiritual life? What could be the consequences if you continue down this path?

DAY FOUR: Probably none of us have gold statues in our house we pray to, but we still have idols. How would you define "idol"? And what are some things in your life that can become an idol to you? How does pride make it difficult to admit we're wrong? Why is being able to recognize and acknowledge error so important in our spiritual lives?

VIDEO: Do you think you have a right estimate of yourself? If not, what hinders your ability to evaluate honestly? Why is it so important that you see yourself rightly? If humility is not just an attitude and attribute but also an action, how are you actively seeking to live humbly? What is something God taught you this week? Why is it so important that you accept God's invitation to live humble?

INVITATION FIVE

YOU ARE INVITED TO

Live Justly

Day One

LAMENT AND REPENT

Unprocessed laments keep our hearts in chains.[1]

Esther Fleece Allen

Another week, another invitation from God to live the good life! I think you deserve a Famous Amos cookie for making it this far!

And hasn't it been good? So far, we've accepted God's invitations to live assured, live faithful, live chosen, and live humble. Living that way is the God life, and the God life is the good life! This week we are invited to live justly.

Let's open that invitation by opening your Bible to Amos 5. We will learn from verses 1-9.

Lord, thank You for Your living and active Word. May it bring life to us and draw righteous action from us. Amen.

All right—coffee poured; heart open; here we go!

READ AMOS 5:1-9. Focus on the first three verses. What kinds of feelings and thoughts was Amos communicating through these word pictures?

Sad, isn't it? We all know what it means to be a virgin in our culture. But in this context, the word depicted youth, innocence, and blossoming potential. Israel hadn't been occupied by a foreign enemy; she was still preserved as a nation. However, that was about to change. This young nation in the prime of life was about to be destroyed.

For Amos to compare Israel to a fallen virgin was his way of grieving loss. The use of "fallen" in the Old Testament usually referred to a tragic or untimely death.[2] Amos bemoaned the nation's wilted beauty, her loss of potential. She was now exposed, vulnerable, and her innocence gone.

The nation's strength was diminished like a dwindling army, like one that had fallen in battle.[3] The whole picture Amos painted in these verses is what scholars call a "lament."

Find the word *lament* in a dictionary and write the definition here. (Or, if you're like me, just ask Alexa®!)

A lament is an expression of grief or sorrow, and it's often poetic. To lament means to mourn deeply, to emote the loss you feel. Since a lament is prompted by situations that cause grief or anguish, list some current issues or situations that prompt you to lament for our world, our country, your community, or your family.

LAMENT LIST:

I know, I know—you probably didn't have enough room to list them all. There's a ton worth lamenting in this life. But lament is tricky stuff, sister. Sometimes we want to avoid it because we fear the depression or free-floating sorrow it may bring. Denial and ignorance feel safer. I get it. I have definitely felt that way.

On the other hand, when we do lament, it can't be a dead-end, you know? We can't simply make a list, grieve the loss, and call it done. If we do, we risk becoming like one of those politicians who is quick to point out all that is wrong—all that needs fixing—but doesn't provide or participate in a solution. A lament is not just a gut-level cry of anguish before God; it should become a soul prompt to seek a solution.

LAMENT IS NOT A FINAL DESTINATION; IT IS A STEPPING-STONE ON THE PATH TO REDEMPTION.

Look back at your "Lament List." Pause, ponder, and pray. Then jot some notes about how God may want you to make your lament a pathway to redemption for the issues, situations, or people you wrote about.

Don't feel intimidated. You are just prayerfully pondering right now, not making a giant commitment! Remember, prayer is always a brave and powerful response.

This was a helpful exercise for me. Instead of dreading lament, I sought what to do with and about my lament. I lament child poverty, and it wrecks me. I pray and often feel helpless or guilty or powerless. My lament found relief, though, as I began sponsoring children through Compassion International. That is just one example of how lament can be a stepping-stone on the path to redemption. Now, four little humans' pictures are stuck to my fridge because I get to sponsor them through Compassion. Those precious kids are now released from poverty in Jesus's name because I was willing to let my lament become a stepping-stone on the path of redemption. If you want to meet Jody, one of the children I sponsor through Compassion International, go to jenniferrothschild.com/amos to see a video of me meeting her.

There are lots of established ministries you can partner with to allow your lament to be a stepping-stone to righteous action. Compassion International is just one, of course. There are even more ways you can respond to God's prompting to your lament concerning your home, community, and church. I am praying for you, for us, sister. We are invited to live justly, and that begins with a willingness to lament, grieve that which grieves God's heart, and then be willing to be part of the solution.

Amos provided a summary of what to do with lament in verse 4. Write it out here in as many translations as you want.

OK, that was a trick prompt. No matter how many translations you checked, the words don't vary much, do they? *Seek God and live.*

You'll love what the word *seek* means in the Hebrew. It denotes investigating, learning, and following someone.[4] Yet in this context in Amos, the word finds its completion in seeking God in worship and surrender. It's related to the Hebrew word *Midrash*.[5] Do you know

what that is? The Midrash is a Jewish commentary on the Scripture. It's called that because it is a compilation of learning, investigating, and seeking to know Yahweh.

Look at the following verses and jot down how each informs what it means to seek God:

Deuteronomy 4:29

Isaiah 31:1

Isaiah 55:6

Hosea 10:12

Lord, we seek You with our whole hearts and souls. We seek no other for our help and our wholeness. Shower righteousness upon us, Your faithful daughters. Amen.

Sister, before we ever seek a solution for our lament, we must seek Him, His kingdom, His heart, His rule, His way, His righteousness.

Amos lamented Israel's demise and urged the Israelites to seek God—repent—to prevent it. If they weren't quite sure what it looked like to seek God and live, Amos made it clear what it did not look like in Amos 5:5. Look at the verbs Amos used to describe what not to do:

Do not:

_____ Bethel

_____ Gilgal

_____ Beersheba

The Israelites couldn't seek God while they were also seeking places of disobedience, idolatry, and self-indulgence.

PAUSE AND READ AMOS 6:4-6 to see another example of the Israelites' lack of lament.

They had no lament and no repentance. They had to make a choice—turn from Bethel and turn to God. Put simply, to repent means to turn away from one thing and go toward the other. Yet the Greek word used in the New Testament for *repent* is *metanoia*, and it means "a change of mind."[7]

Amos's lament in chapter 5 is written like a funeral dirge. The original Hebrew carries a poetic beat pattern of 3/2, 3/2.[6] This poetic device is often used in the book of Lamentations. This form characterized funeral songs or chants, and the Israelites would have recognized what Amos was doing—setting the stage for their funeral.

Sister, true repentance changes the way we think about ourselves, our sin, our world, and our God. It transforms our outlook; it reorients us. True repentance changes our minds and then changes our actions.

REPENTANCE IS PART OF THE GOOD LIFE.

Yellow light: If you aren't exactly sure what it looks like to seek God in your life, consider what it looks like to seek your own version of "Bethel."

> **PUT DOWN YOUR PEN. PAUSE AND READ MATTHEW 6:24.** Ask God to reveal to you if you are trying to serve two masters—if you struggle with divided loyalty between God and anything. Sister, we all have Bethels we seek. But I'm praying your heart and mine is to seek God and live, so ask Him to guide you here. Don't pick back up with this study until you've had a "change of mind"—a time of repentance.
>
> OK, moving on. Let's remind ourselves of the context of Amos's lament here. It's summarized in Amos 5:7. What was the lament about and what was the repentance for?

Amos was both heartsick and fired up over Israel's corrupt legal system. Justice was rotten, and righteousness was buried so deep in Israel's history that the Israelites trampled the memory of it. Matthew Henry wrote that if Israel "will seek and love that which is good, [it] may help to save the land from ruin. It behoves us to plead God's spiritual promises, to beseech him to create in us a clean heart, and to renew a right spirit within us. The Lord is ever ready to be gracious to the souls that seek him; and then piety and every duty will be attended to. But as for sinful Israel, God's judgments had often passed by them, now they shall pass through them."[8]

Ouch, Matt! You got that right. And it feels so wrong because it didn't have to happen that way.

You know, I think if we only look "out there" and focus our lament on the state of our country, the state of the church, the state of our neighbor, we may overlook our own sin—a condition that should have its own lamentation. We must first grieve over our own sin and repent, and then we are better qualified to discern and lament the sin and suffering of others. Without personal lament, pride creates an "us versus them" mindset. We then become the modern equivalent of the cows of Bashan—consumers of Christ's message instead of carriers of Christ's mission.

So, what do we do with this? We, like Amos, lament, and, unlike Israel, we repent. We let lament be fuel for repentance. And then, sister, we look to the stars.

READ AMOS 5:8-9.

This is a poetic doxology Amos offered to God as the Creator and ultimate Judge. (By the way, there are two more doxologies in Amos, Amos 4:13 and 9:5-6.)

Why do you think Amos pulled Israel's gaze upward? What was he doing by summoning their attention to the grand universe? If you need a little help, just Google "Pleiades" and "Orion," and you'll be blown away.

It's like Amos was saying, "Look up and around. See how mighty and worthy your God is? This is who you seek."

Amos was reminding the Israelites, who, in their own minds, were grand, that they weren't. God is worthy of being sought because He is the sovereign God of this universe. Some Israelites had turned the created planets into idols, and Amos was calling them back to the truth that Yahweh alone makes and upholds starry constellations. He manages all the forces of nature. He alone is God and is mighty enough to save them or squash them. Personally, I think I'd be singing, "Praise God, from whom all blessings flow; Praise Him, all creatures here below" while I shook in my sandals and lifted my hands in worship![9]

So where does this message meet you? I'll be honest: this was one of the hardest days of study for me to write. I rewrote it three times! It may seem like a simple couple of thousand words to write, but they're deeply difficult words to live. I finally realized I had to feel it deeply and live it authentically before I could really write it. So for the past two weeks, I have begun a practice of lament. I've been drawn to it although it has been hard. I lament my own sin and want to truly lament the devastation of sin and evil in our world. And, sister, I have been so sensitized to repentance—cleansing, mind-changing, freeing repentance. I don't want to mindlessly seek "Bethel." I want to turn from anything other than my good and righteous God. He alone deserves the fruit of my lamentation, my repentance, and my whole life.

So, woman of God, let's seek God and live. Let's start this week's journey with clarity. To live justly begins with a willingness to lament and repent.

> Before you close your book today, write out James 1:22 on a sticky note or on that cute chalkboard in your kitchen. Constantly use it as a prayer prompt this week to help you live out this truth in Amos. We don't want to be women who just know the truth. We want to be women who live it!

Love you big time! See you tomorrow.

Day Two

HATE EVIL; LOVE GOOD

The omission of good is no less reprehensible than the commission of evil.[10]

Plutarch

———

Come with me to the first day of tenth grade. My mom will drive us in our groovy Ford® Fairmont. We're in Miami, Florida, and it's the eighties. You and I are both wearing high-waisted chinos, skinny belts, espadrilles, and, of course, Oxford shirts. And, girl, it is hot. But we are teens, so we barely notice the heat. We only notice the boys. A new boy shows up. Everybody notices. Everybody is whispering. It's really obvious really fast that this boy is not going to be one of the cool guys, not one of the populars. I can't see his face or his clothes because I am already legally blind, but who needs to see him when we have such a well-formed, advanced, sophisticated gossip structure in our class? I have already learned he has greasy hair, acne, and his clothes are very uncool. We'll call him "Mike," though that isn't his real name. His real name is ordinary, normal, quite acceptable to a judgmental group of fifteen-year-old critics. OK, got the picture?

I clued in really fast that Mike was an outsider. And I felt for him. I really did. So I befriended him. But I wanted so much to stay in the popular group and for everyone to still think I was cool. So trying to be kind and cool at the same time, I gave Mike a nickname: Egbert. That wasn't the actual nickname, but you get the nerdy idea. (And forgive me if Egbert is your dad's, husband's, or son's name, please.) I chose a nickname that accented his awkwardness and outsider status. Of course, I'm ashamed to say I was making fun of him. And everyone laughed. It worked. I was still cool. Egbert became his new name thanks to me. Every time a classmate used Egbert, they were mocking Mike.

Now, sister, I genuinely, totally regret this. I was so immature and insecure. I have asked God for forgiveness a million times, though I'm sure once was enough. I've never been able to track down Mike and apologize. I was taking advantage of him for my own selfish gain. He needed my loyalty and kindness—not to be used to prop myself up and look cool in front of my classmates.

Mike could have been one of the cast of characters in Matthew 25:31-46. He was definitely one of the "least of these" in our high school, and I got the most out of it for myself. So, I want to read Amos 5 today through the lens of Matthew 25 to see what it looks like to seek good, not evil, and live justly.

READ AMOS 5:10-15. Pause and pray for the Holy Spirit to be our Teacher today.

FOCUS ON AMOS 5:11-12. Jot down Israel's violations and consequences.

Verse 11a—violation:

Verse 11b—consequences:

Verse 12b—violation:

The elite Israelites were messing with "the least of these." They were oppressing the poor, exploiting and overtaxing them, and denying them justice at the gate.

Do you know what the "gate" was back in Amos's day? It wasn't just a big iron contraption that swung on hinges to keep the good guys in and the bad guys out. It was also the location that served like our courthouse.[11]

Suppose you live in eighth-century Israel and you are a widow, orphan, or immigrant facing legal trouble. You have no power and no influence. There is no public defender or educated uncle to plead your case. But these are God's people, right? Surely they won't mistreat you. These are the people who follow Yahweh, and He is a just and righteous God. You have some protection under the moral law that God gave Israel, don't you? So you head to the city gate and plead your case. You throw yourself on the mercy of the court. But you end up worse off—exploited, taken advantage of, overcharged, and made to pay.

How would you feel as you left the city gate?

Angry. Resentful. Powerless, Devalued. That's how I would feel. And, quite honestly, I would be like, "And these are supposedly the righteous people of the one true God, Yahweh? Really?"

There can be no true righteousness toward God without justice toward others.

OK, KEEPING THE CITY GATE EXAMPLE AND MY TENTH-GRADE BAD BEHAVIOR IN MIND, READ MATTHEW 25:34-40. Sketch or note how Jesus expects us to treat others.

What six examples of people show up in verses 35 and 36?

Verse 35

1.

2.

3.

Verse 36

1.

2.

3.

What do those examples have in common?

Needy people. Helpless people. Powerless people. Matthew 25:40 calls them "the least of these." Yet Jesus made it clear that these are "brothers and sisters"; these are with whom the King in the story identifies. So, if you transfer Jesus's teaching in Matthew 25 to what was going on in Amos 5 in the corrupt courts, who was really being mistreated? Who continues to be mistreated when the widow, orphan, poor, immigrant, or new boy at school gets exploited?

God cares so deeply that we treat others with justice and righteousness, and when we don't, He feels it. It's as if we have mistreated God Himself.

LOOK AT PROVERBS 14:31. How are we treating God when we mistreat others?

Likely you aren't involved in overt injustice or exploitation of the poor. But injustice can show up in the most subtle ways—think "Egbert" situations. When that happens, it's as if we are throwing contempt on God, because He is their Maker. Each person bears God's image, so to slander His creation is to slander the Creator.

Have you had any "Egbert" kind of experiences where you have not treated "the least of these" righteously or justly? Or have you ever been one of "the least of these" who has been on the hard end of someone's unjust or unrighteous behavior? Describe what you experienced in either or both situations and how you felt.

Sister, no matter whether you are the one who regrets mistreating someone or if you are the one who has been mistreated, "The LORD is gracious and compassionate, slow to anger and rich in love" (Ps. 145:8, NIV).

Pause here and get this settled with your gracious Father God.

OK, one last thing in Matthew 25 before we get back to Amos. Circle the word that describes what Jesus called the people who answered the King in verse 37.

Good Righteous Socially Conscious Ministers Volunteers

My friend, you are made righteous through Christ when you receive Him as your Savior and Lord (2 Cor. 5:21). Yet righteous is not just a position; it is a practice (1 John 4:20).

RIGHTEOUS IS NOT JUST WHO WE ARE. IT'S WHAT WE DO.

The rich Israelites built their wealth by exploiting the poor, just like I built my tenth-grade social cred by exploiting Mike. Instead of investing in what God was invested in, they neglected and rejected what mattered most to God. They made the most of "the least of these" for their own selfish gain.

God said in Amos 5:12 He considered Israel's sins "manifold" and "mighty" (NKJV). Girl, that means they were big and many! Ouch.

In fact, how does Amos 5:13 describe the time they were living in?

The days were evil for sure.

But Amos gave a solution in Amos 5:14-15. What was it?

"Seek good and not evil." "Hate evil, love good." These may sound like just simple phrases, but think about it. Amos was speaking to the elite of Israel who were really good at arguing legal points, while at the very same time taking bribes, corrupting justice, and making a mockery of God's moral law. Amos reduced what it means to live justly into two indisputable actions. Let's see how we can apply God's Word to our lives.

1. SEEK GOOD. LOVE GOOD.

In Hebrew, the word we translate as *good* means "a good thing, benefit, or welfare."[12] Look back at your Lament List from yesterday (p. 119). How can you seek or create a good thing from one of those bad situations?

Are there practical ways you can help people who are suffering? How can you increase their welfare?

READ AMOS 5:4,6,14 back-to-back out loud. Go ahead—only the dog will hear you!

Do you hear that? Ultimately, seeking God and seeking good, loving God and loving good, are inseparable. So, sweet sister, if you are truly, genuinely seeking God, you will seek good in every situation you encounter.

2. HATE EVIL. AVOID EVIL.

In Hebrew, the word used in Amos 5 for *evil* means—wait for it—evil. We know what Hitleresque evil looks like—wicked, cruel, heinous. But this word is also translated as "distress, misery, injury, [or] calamity."[13] So let's think about this in two ways.

Think about that Hitleresque definition of "evil." How can hating this kind of evil promote justice?

How can "hating" people's distresses, miseries, injuries, and calamities promote justice?

Sister, we need to determine what evil is and do nothing to contribute to it. Perhaps you need to pause and define what evil is. Name it. Sometimes evil is blatant and brutal. But sometimes it's so subtle or we are just so plain used to it that we don't notice it anymore. If it can't stand beneath the righteousness of God, it is evil.

We may not be able to eradicate evil on this earth, but we can avoid contributing to it, and we can seek to do good to offset it.

Ask God to grant you wisdom to hate evil in very practical ways.

This may be a little tricky. I get it. But perhaps we start by assigning the strong emotion of hate or disdain to human suffering, which can heighten our awareness and sensitize our hearts to view sin and suffering as God does. That strong emotion often prompts a strong response.

The people of Israel were given a chance to do the right thing—clean up the corrupt courts and establish justice in the gates for all people. We are given the high privilege to seek good, promote good, and become an active force against evil so justice prevails.

That means we do something. (Tomorrow we will look at Amos 5:10,13 to understand how and when we should also say something.)

Lord, give us the courage and wisdom of Amos to be Your hands and voice and heart so justice will roll as waters and righteousness as a mighty stream. (See Amos 5:24.)

And all the sisters said, "Amen!"

Do not be wise in your own eyes;
Fear the Lord and shun evil.
Proverbs 3:7

Day Three

UNCLOG THE
JUSTICE STREAM

Injustice anywhere is a threat to justice everywhere.[14]

Martin Luther King, Jr.

Hey, my friend! What a week so far, right? Amos is giving me a heart education on what it looks like to live justly, and I'm getting a whole new view of the good life. So, before we open the Bible, I want you to read part of a letter written by Martin Luther King, Jr., from a jail cell in Birmingham back in April of 1963.

I am in Birmingham because injustice is here. Just as the prophets of the eighth century B.C. left their villages and carried their "thus saith the Lord" far beyond the boundaries of their home towns, and just as the Apostle Paul left his village of Tarsus and carried the gospel of Jesus Christ to the far corners of the Greco-Roman world, so am I compelled to carry the gospel of freedom beyond my own home town. Like Paul, I must constantly respond to the Macedonian call for aid. Moreover, I am cognizant of the interrelatedness of all communities and states. I cannot sit idly by in Atlanta and not be concerned about what happens in Birmingham. Injustice anywhere is a threat to justice everywhere.[15]

Martin Luther King, Jr. wrote these words to fellow clergy who had expressed their concern about his methods and his timing. He was an exceptional example of speaking out and stepping up when he saw injustice.

There are times we speak and times we remain silent, but we never remain stagnant when it comes to injustice. Let's start today by reading two verses in Amos 5 that we skipped over yesterday.

READ VERSE 10 AND VERSE 13.

Lord, speak to us through Your Word. Amen.

What does verse 10 say about those who were standing and speaking up against injustice?

Why do you think the Israelites hated the one who spoke up?

Nobody likes to hear she's in sin, especially if she doesn't like the sin she's in! Of course, Amos and any other righteous person who spoke out got pushback.

How does verse 13 describe the result?

The prudent were silent. Or maybe they were silenced? *Hmm*. This verse is difficult to understand and scholars are unsure of its exact meaning. But let me point out one thing I see here. Amos was not giving a blanket statement condoning silence; instead, he was describing a moment in time. This is one of those verses that you must read as descriptive, not prescriptive. It is not instructing us or giving us permission to stay quiet and let evil flourish and people get abused.

To me, it seems Amos was saying that the days were so evil that the prudent were unable to speak out. But, sister, that didn't mean they weren't still to seek good. Even when you can't speak out, you can speak to God in lamentation and seek good.

Lord, help us to know when to speak up and step in. Help us to love what You love and hate what You hate. Give us discernment and integrity as we seek good and live justly. Forgive us when we overlook or underestimate what You value. Amen.

> Girl, if you have never read that whole letter by Martin Luther King Jr., you need to. I felt it deeply and was so moved by his moral clarity and commitment to unclog the justice stream. Take a few minutes to Google it and read the whole letter.

Now, let's look at Amos 5:16-27 to learn how to unclog the justice stream in our lives.

READ AMOS 5:16-27.

OK, let's start with verses 16 and 17 and get all the crying out of the way! Amos was describing a response to coming loss and grief that would call for professional mourners. (See Jer. 9:17-18.) Professional mourners were hired in the ancient East just like funeral singers are hired in the West today.

It's hard for us to grasp this Eastern custom. But if you ever heard it, you'd know wailing is the sound of death.

> **READ MICAH 1:8. Jot down how Micah described the sound.**

It was so intense that the prophet Micah compared it to the keening and cries of wild animals. Yet Amos was saying the sorrow would be so deep that there wouldn't be enough professional mourners to cover it. The farmers would be pulled from the plow and handed a Kleenex® to take up the lament. Israel would cry a river because she had not let righteousness flow like a mighty stream.

> **LOOK AT AMOS 5:24 AND GET THAT IMAGE IN YOUR MIND. This was God's intent for His people, yet the stream had stopped. There was a clog in the nation's justice and righteousness flow.**

Let's see how they got this so wrong. How did the Israelites clog up the justice flow?

THREE WAYS ISRAEL CLOGGED THE JUSTICE STREAM

1. Israel was starry-eyed instead of clearheaded.

> **READ AMOS 5:18-20. What were the Israelites looking forward to in verse 18? What question did Amos pose to the Israelites about it?**

Amos and the Israelites had different ideas when it came to what the day of the Lord would be. The proud Israelites likely focused on how the day of the Lord would affect their enemies. After all, they heard that searing sermon from Amos in chapter 1 when he pronounced judgment on Israel's neighbors.

> **READ ISAIAH 2:12 AND JOEL 1:15 from the perspective of the smug Israelites.**

See? It was payday for the bad guys as far as they were concerned.

But for them? Safety, wealth, and power. We don't know their exact expectations, of course, but based on their general attitudes and actions in the book of Amos, I don't think that is far off. Self-interest guided them. Self-absorption consumed them. Self-delusion was the result.

How did Amos describe the day of the Lord at the end of Amos 5:18 and Amos 5:20?

Usually, when writers use the word *darkness*, what are they trying to communicate? What is intended with the use of *light*?

The starry-eyed Israelites thought that their future was light, hope, and promise—not destruction, death, and despair.

But sadly, the day of the Lord for these ancient Israelites did not hold the promise and hope of an Eden sunrise. Rather, it would be like the opposite of that first light of Creation. It would be Israel's undoing.

What was Amos communicating about the nature of that day in verse 19?

Doesn't that sound stressful? *You run from a lion, think you are safe, and—deep breath—a bear jumps out and snaps his hungry jaws in your direction. But you make it home safe, burst through your front door, lean on the wall to catch your breath, and a snake slithers out from the crack in the wall and takes a bite out of your hopeful delusion.* Unsafe. Unavoidable.

The Israelites were so self-deluded that they had evidently glossed over their actions and had a totally wrong concept of their holy God and His Word.

We want to be clearheaded. We want to have a right estimate of ourselves, not live in self-delusion. Pray through the following verses to help you assess your spiritual standing before God. Ask Him to give you a clear head.

Psalm 4:4

Matthew 7:5

2 Corinthians 13:5

If we are not clearheaded, we will not rightly assess and apply truth. A wrong estimate of ourselves keeps us from a right relationship with God and others.

Oh, Lord, may we be clearheaded. May we have a right estimate of ourselves and a right understanding of You. Drain our self-absorption. Undo our self-delusion. Flow through us like a mighty river, cleansing us and refreshing others. Amen.

2. Israel placed ritual above relationship.

READ AMOS 5:21-23. What words stood out to you in these verses describing God's feelings about Israel's rituals?

How would you feel if this was God's heart about your latest women's Bible study gathering, church service, or Christian concert?

The Israelites were observing exactly what they should have as the people of God. They were gathering (Lev. 23:26ff) and sacrificing (Lev. 1–7) just as the Law required. They were participating in corporate praise (2 Chron. 7:6; Amos 6:5). They did all the right things, but it rubbed God the wrong way. Why? (Read Isa. 29:13 for a hint.)

They were crushing it when it came to religion and totally blowing it when it came to relationships with God and others. Relationship with God prompts just action.

Israel's worship and obedience were the fruit of a rotting grave when God desired the fruit of true worship and obedience—a mighty river of justice and righteousness flowing over and through His people.

God wasn't saying He hates ceremonies, gatherings, and music! Of course not. Yet God will not regard hands raised in worship when they are stained with injustice. God refuses sacrifices from those who do not practice righteousness. God will not hear songs sung by a choir who neglects or exploits the oppressed.

Oh, sister, God loves our worship and our acts of faith when they spring up from the ever-flowing well of a people who are sincerely just and righteous.

Oh, Lord, You have shown us what is good, what is right, and what You require. That is what we want, nothing less. May we act justly. May we love mercy. And may we walk humbly with You all our days. Amen.

3. Israel had divided loyalty.

Read the rhetorical question Amos asked in 5:25. Do you know the answer? *Hmm.*

Don't worry if you're a little fuzzy on this. This part of Amos 5 can be a little smudgy! Amos was expecting the listeners to furrow their brows, shake their heads, and say, "Nope." Here's why. During the forty years in the wilderness, Israel didn't offer sacrifices. It seems the sacrificial system was reserved for the promised land. So what point was Amos making here?

Well, God just told the Israelites how He felt about their insincere ceremonies, sacrifices, and music, right? And then He mentioned the wilderness where little, if any, of that happened. What do you think God was communicating here?

Faithfulness expressed in loyalty, justice, and righteousness is what God values most. This gets right to the heart of worship. So, gather with your Bible study buddies, worship together with your church, and lift your voice to Jesus! Yet, as you do, remember those become empty expressions of worship if true worship is not expressed through righteousness and justice that flows from a pure, humble heart devoted to God.

Well, sister, we dealt with a lot today. Review your notes and jot down a few things you feel led to pray through. I'm trusting God along with you that He who begins a good work in you is carrying it to completion.

Day Four

PAY ATTENTION
TO THE FRUIT

We do not fail to enjoy the fruit of the Spirit because we live in a sea of corruption; we fail to do so because the sea of corruption is in us.[16]

Billy Graham

Hop on, sister, the Amos train is going in a direction today you may not have expected. So, all aboard! We're leaving chapter 5 and headed for chapter 8, with a quick stop off in chapter 6. We're going to take a look at Amos's fourth vision (8:1-3) to understand how fruit in our lives helps us know if we're living justly.

If you're concerned that we're getting out of order, my type A friend, no worries. Next week we'll dive into the other visions of Amos. But for now, let's check out the fruit!

> **READ AMOS 8:1-10. As you read, take notes using the prompts below to guide you.**
>
> **Note the comparison God made between Israel and fruit in Amos 8:1-3:**
>
> **Note the theme of Amos 8:4-6:**
>
> **Note the theme of Amos 8:7-10:**

Amos, the wordsmith, repeated his message to Israel in a different way: Israel was ripe for judgment. God, through Amos, reminded His people why this judgment was inevitable. They had exploited, oppressed, cheated, and not lived justly. There's even a crafty wordplay here in the Hebrew between God and Amos which revealed that Israel's end was near. "So when Amos replies to the Lord that he sees a basket of ripe *qayits*, God replies, '*Qēts!*' An end is to come upon Israel."[17] While these Hebrew words have different roots, in the time of Amos, they would have been pronounced similarly.[18]

Well, my friend, every time I think of this basket of ripe fruit, I can't help but think of fruit spoiled by unrighteous hearts.

POP BACK TO AMOS 6:12 TO SEE THIS. Consider what God may have been pointing out to His people about fruit.

Would you expect the Kentucky Derby to be run on a cliffside track? What would happen if horses were sent to run over rough rocks and boulders? Likely they'd stagger, stumble, and be injured. The Lone Ranger® wouldn't expect things to turn out great if he sent Silver down a rocky path. "Hi Ho, Silver! Oh no, Silver—down we go, Silver!" Neither would a farmer take his team of oxen to try and plow that kind of ground.

So what does this have to do with fruit?

Just like you wouldn't expect that a horse's journey on a craggy path would turn out well, nor oxen plowing up boulders, the Israelites shouldn't have expected a good result since they had "turned justice into poison and the fruit of righteousness into wormwood" (ESV). Justice and righteousness should be sweet fruit of the righteous life. Yet the Israelites made them bitter poison because of the actions springing from their poisonous hearts. It was a mockery of what God intended. Fruit reveals our hearts.

READ GALATIANS 6:7. What did Paul say in these verses about God?

God is not mocked, right?

What does Amos 8:7 suggest about God's memory when it comes to injustice and sin?

God does remember willful sin and oppression of others. He will never forget sins without repentance. Because of their stubborn hearts, the God who was willing to forgive now refused to forget.

On the flip side, God remembers the good we do. *Whew!* When we walk in the Spirit and bear the fruit of the Spirit (Gal. 5:22-23), God will not forget that either. Paraphrase and personalize Hebrews 6:10 as if God were speaking directly to you.

I, God, am . . .

God is just. He sees your good fruit. He will never forget your labors of love. On the days when you think nobody sees how you give, serve, and love, when you wonder if it even makes a dent in this big mess of suffering that is our world, read what you wrote. God sees. God pays attention. God cares.

> **NOW READ GALATIANS 6:7-10 and keep the Israelites in mind as you do. How do these verses speak to the fruit of righteousness that had turned bitter in Israel's life?**

> **What can you apply from these verses to help you pay attention to your own fruit?**

Sister, sometimes I wonder if my fruit is sparse. I wonder if it is enough. I do get weary of doing good because I wonder if it does any good. At. All. Yet these verses in Galatians encourage me that there will be fruit; there will be a harvest even though I may not see it. God is not mocked. Just as unrighteous seeds will bear a bitter harvest in one's life, so will works of righteousness bear a beautiful harvest.

You know what else these verses help me with? They reduce a little of the "social justice overwhelm" I often feel. You know that feeling? You get online and hear all the needs, read about all the wrongs, what you should do about them, how you aren't doing enough, and how if you were just "all in" and down for the cause, the world would be a better place. But am I all in? Maybe I'm just worked up and freaked out. It is all too much! So many problems, so little of me. And because I can't do everything, I feel I can't do anything.

Yet an amazing phrase in Galatians 6:10 lets me breathe and feel less overwhelmed: "as we have opportunity" (CSB). Yep, that is what God's Word says. As we have opportunity, let us do good to everyone. Oh, sister, that helps me so much. In this day of one-touch access to every world tragedy, I'm made aware of every need, but I do not have opportunity to meet every need. I want to do good, yet my knowledge of the problems is far greater than my capacity to engage them. Do you ever feel that way?

Sister, living justly means we pay attention to the opportunities and pay attention to the fruit.

The righteous woman is filled with and lives by the Spirit, and the result is fruit. The fruit of the Spirit is listed in Galatians 5:22-23. Find those verses and list the fruit below. Then write the fruit into a prayer of opportunity to live justly.

Here's mine: *Sovereign Lord, I want to live loved and show Your love to everyone I encounter. May I bring Your joy to the discouraged and may it be strength to them. When I am caught up in conflict or surrounded by chaos, may Your peace be my response. When others test my patience or treat me wrong, may the fruit of forbearance make the situation sweeter.*

Grant me the grace to show kindness to the disagreeables and goodness to all. May I show faithfulness to Your Word, Your will, and what You value, Lord. May my gentleness be obvious to all as I act and react with humility and self-control in every opportunity You give me. Amen.

Your turn:

Caring people can experience what John Eldredge calls "empathy overload" because the trauma of the entire world is delivered to us hourly on our devices. However, our souls weren't meant to know all the suffering of the world. Listen to episode 93 of my *4:13 Podcast* where John Eldredge helps you know how to release everything and everyone to God at 413podcast.com/93.

4:13 Podcast, episode 93

Lord, guide us to seek good and do good. Awaken us to the opportunities You put before us and may You find us faithful. Amen.

Sister, you prayed that the fruit of the Spirit would be on display in your life in the opportunities you have to do good. Now, look at the following verses to see very practically what fruit God likes. Like, if He were in the produce section of your heart, what would He choose? Write beside each reference what God is telling you and me to do.

PSALM 41:1-3	
PSALM 112:5	
PROVERBS 11:25-27	
1 TIMOTHY 6:17-18	
HEBREWS 13:2	
HEBREWS 13:16	

Girl, show hospitality to strangers. Do good and share with others because it pleases God. Give to the poor and take care of the weak. Refresh others and seek good. God notices all that sweet fruit, and He will refresh you, take care of you, and show you favor. Be rich in doing good! This is the fruit God never forgets.

When we live with pure hearts, the stream of justice flows through us and the stream of righteousness refreshes those who get caught up in the flow. Instead of a sea of corruption filling our hearts, producing bitter fruit, the fruit of the Spirit is daily nourished in our lives, springing forth in good works.

When we live with the awareness that we have a just Judge who pays attention to the fruit, we will, as Micah put it, seek to act justly, love mercy, and walk humbly with our God (Mic. 6:8). May it be, Lord.

Oh, sister girl, Invitation Five is a wrap! Way to go! Tomorrow spend your Good Life Day pondering and living out what it means for you to live justly.

Love you,

Jennifer

Day Five

YOUR GOOD LIFE DAY

Lord, I receive Your invitation to live justly.

Where did the message meet me this week?

☐ I want to begin a practice of lament in my life.

☐ I need to have a change of mind, true repentance, in some areas of my life.

☐ I desire to be more strategic when it comes to being a force for good in my community and in our culture.

☐ I am seeking to live with a pure heart so justice and righteousness will flow through me.

What would my life look like if I regularly practiced lament and repentance?

What is one practical way I will seek good and shun evil this week?

How can I practically let righteousness and justice flow through my life?

In what area of my life do I need to pay attention to the fruit?

This week, God taught me . . .

MY GOOD LIFE DECLARATION

To live the good life, I will live the God life and . . .

I will let go of:

I will trust God with:

To make your Good Life Day even better, listen to my #GoodLife playlist at jenniferrothschild.com/amos.

I will take hold of:

To access the video teaching sessions, use the instructions in the back of your Bible study book.

INVITATION FIVE:
Live Justly

BEFORE THE VIDEO
Welcome and Prayer

VIDEO NOTES

Justice is not _____. Justice is righteous _____.

Three elements of living justly:

1. _____ action

2. _____ action

 Two elements to our private action of living justly:

 1. _____

 2. _____

3. _____ action

The foundation of God's throne is _____ and _____.

Would you like to read my written summary of this video teaching? Just go to jenniferrothschild.com/amos to get a summary emailed to you.

CONVERSATION GUIDE

DAY ONE: What are some current issues or situations that prompt you to lament for our world, country, community, or your family? A key phrase in Amos is "Seek God and live." What does that mean to you, and how are you currently living that out?

DAY TWO: Who are the "least of these" in your community? How are you and your church seeking to meet their needs and treat them righteously and justly? What does it look like for you to hate evil and avoid evil?

DAY THREE: How does our self-interest get in the way of treating people righteously and justly? The Israelites had lost sight of the true character of God and His purposes in the world. Does that ever happen to you? Explain. How can you maintain a right understanding of God and His ways?

DAY FOUR: If fruit reveals our hearts, what is your fruit revealing at this moment about the status of your heart? Do you ever grow weary of doing good? Explain. What's the main culprit that zaps your strength to do good? How can you guard yourself against this kind of exhaustion?

VIDEO: What does it look like in your life to shun evil or actively oppose it? Is lament a part of your prayer life? If so, in what way? If not, why should it be? What is something God taught you this week? Why is it so important that you accept God's invitation to live justly?

INVITATION SIX

YOU ARE INVITED TO

Live Prayerful

Day One

THE INTERCESSION

Intercessory prayer might be defined as loving our neighbor on our knees.[1]

Charles Brent

Here we are, sister, Amos chapter 7, and we're opening another invitation. We are invited to live prayerful. Did you notice I didn't write, "We are invited to pray"? Nope. We are invited into a lifestyle of prayer, and Amos will show us a particular way to do just that because prayerfulness is part of the good life!

Get your favorite Amos snack. Do you have one by now? Mine has gotten healthier over the last few weeks—dried figs, raw almonds, Lily's® dark chocolate chips, and, of course, dark, strong, hot black coffee! I just think better with coffee!

Gather your stuff, open your heart, and open your Bibles to Amos 7.

Lord, along with Your disciples, we ask, "teach us to pray" (Luke 11:1). Give us spiritual insight to understand Your Word through Amos and empower us to live it. Amen.

Last week we looked at one of Amos's visions. Remember? The basket of summer fruit? Well, this week we'll look at some more visions. Today's are quite buggy and hot.

START BY READING AMOS 7:1-2.

Lots of details are in these two little verses that give us tons of insight, so let's do a slow read.

How did Amos describe God in verse 1?

Amos used different names for God throughout his message, using "Lord" (Jehovah) the most. Yet there are several places where he combined "Adonai" with "Jehovah." In most versions, this combination is translated as "Lord God." But the NIV translates it "Sovereign Lord."

So let's park here for a minute and take a look at what it means for God to be sovereign and how that relates to Amos's message.

Start by looking up the dictionary definition of *sovereign*. Write it below.

Your dictionary definition of *sovereign* probably said something like having "supreme power or authority."[2] How does that definition fit with the character of God we see described throughout Amos's prophecy?

God is the royal King. He has supreme rank, power, and authority. God is above all others in character and importance. And it is this God, the sovereign God, who is showing Amos this vision of destruction.

Note the details. When were these winged objectionables swarming? (See v. 1.)

Think about what a field looks like right before harvest time. It's full, right? In Israel at this time, taxes were paid by means of the king's court getting the first picking.[3] In Amos's vision, the locusts swarmed after the "king's mowing." That means the bounty that came with the second crop was all the Israelites had left to feed themselves and their stock.[4] But according to Amos's vision, that second harvest would be swallowed up like Happy Meals® by an army of hungry insects. Locusts were nothing to mess around with.

Their numbers exceed computation: the Hebrews called them "the countless," and the Arabs knew them as "the darkeners of the sun." Unable to guide their own flight, though capable of crossing large spaces, they are at the mercy of the wind, which bears them as blind instruments of Providence, to the doomed region given over to them for the time. Innumerable as the drops of water or the sands of the seashore, their flight obscures the sun and casts a thick shadow on the earth.[5]

CUNNINGHAM GEIKIE

READ EXODUS 10:13-15 to get a picture of locusts in action.

READ AMOS 7:2 AGAIN. Now that you're a locust expert (*wink*), what Amos said in verse 2 makes a lot of sense, doesn't it? What kind of emotions can you read within the words Amos expressed here?

I like how the NIV translation tries to capture the emotion by stating that Amos "cried out." Perhaps it was sorrow or panic or despair or fear. We can only imagine the feelings. Yet we know to whom Amos cried out—the sovereign Lord. Amos knew the flight of the locust was at the mercy of the wind, or better put, under the sovereign rule of the Maker of the wind. So he prayed.

PRAYER IS PART OF THE GOOD LIFE.

Write the simple prayer Amos prayed in Amos 7:2.

OK, pause here. Instead of reading through to God's response to Amos, I want you to see another vision Amos had and what he prayed afterward.

READ AMOS 7:4. Describe this vision.

Yeah, grab the fire extinguisher! This was like a scorched earth judgment. Fire would dehydrate the ocean and turn the land to ash. This type of judgment is no surprise to us by now, right? God had promised in one way or another, through Amos, that judgment was on the way, and it wouldn't be pretty. So Amos prayed again.

LOOK AT AMOS 7:5. What does this prayer have in common with Amos's prayer in verse 2? (Maybe the easiest way to answer this is to note the differences.)

In verse 2, Amos asked God to forgive. In verse 5, Amos asked God to stop!

If we were there with Amos and we spoke Hebrew, we would have heard Amos using his boss voice. When he asked God to forgive and stop, he was using commands: "Forgive!" "Stop!" Just the way Amos said it reveals urgency and intensity. The visions must have been so overwhelming they conjured up a hoard of emotion, an inferno of passion. And what Amos said next to God reveals what that emotion must have been based upon.

How did Amos describe Israel in verse 2 and verse 5?

Amos called Israel, this mighty, haughty nation, *Jacob—small Jacob*.

Think about what you know of Israel during this time, based on what we've studied. Write down a few adjectives you would use to describe Israel to your BFF who doesn't know much about them.

Amos didn't call Israel rich or prosperous. He didn't mention the Israelites are God's chosen people. Amos didn't appeal to God based on Israel's righteousness, did he? Neither did Amos appeal to God on Israel's behalf based on the Israelites' repentance. Amos interceded for the Israelites based on their need and God's character.

Israel is called Jacob, a reminder he was the smaller, younger one to Esau in Isaac's family; God had deliberately chosen him and therefore was obligated to stand by him in his helplessness.[6]

DAVID HUBBARD

Some scholars interpret Amos's words here as a genuine, emotional plea. This blustery prophet of doom actually had a tender heart toward God's people.[7] Yet others think Amos was being Amos—he was being legally correct, presenting a forceful argument to God that totally destroying Israel would be a breach of contract, a broken promise from the God of the Covenant.[8] I'm not sure which is correct, but I lean toward the former. I like to think that under Amos's gruff exterior was a tender heart moved with compassion, willing to intercede.

If prayer is intimidating for you, you need to hear my conversation with Anne Graham Lotz on episode 123 of the *4:13 Podcast*. She'll help you overcome your struggle with prayer. Just go to 413podcast.com/123.

4:13 Podcast, episode 123

Amos the shepherd, who bound up injured lambs and perhaps had a heart to leave the ninety-nine to find the one, had a compassionate heart toward the stubborn sheep of Israel—those who, like sheep, had gone astray, each one to their own way. He cried out to God on the nation's behalf.

Amos interceded. And that's where we will end today, intercession. Tomorrow we'll read how God answered, but for now, I want us to ponder the power and privilege of intercession.

Put simply, intercession is not about me praying for me or you praying for you! Intercession is about me praying for you and you praying for me—the act of praying on behalf of someone else. To have a heart to intercede, you have to see people for who they are, not just what they do or how they behave, just like how Amos saw Israel as frail, small Jacob.

Who do you get to intercede for? Who in your world is small and frail and needs support from God? Look at the following options given to us by Scripture.

Who is in authority you can intercede for (1 Tim. 2:1-2)?

What ministers in your life can you intercede for (Phil. 1:19)?

Who are friends you need to intercede for (Job 42:8)?

How can you intercede for those who don't know Jesus (Rom. 10:1)?

Who are the sick or injured you can intercede for (Jas. 5:14)?

This one is hard. But is there a difficult person in your life you need to intercede for (Matt. 5:44)?

My friend, intercession is part of the good life because intercession is not about us. It is God-centered and other-centered. Intercession frees us from ourselves, aligns our hearts with God's heart, and is part of God's way of accomplishing His will.

Even though I gave you a list of several scriptural intercession options, just pick one for this week and practice what we have learned.

I commit to intercede for _____
for the next seven days.

Lord Jesus, thank You for setting the example of intercession for us. Thank You for never stopping interceding for us frail, fallen creatures. May we be women driven by compassion and drawn by grace to pray. Hear our prayers, Lord. Amen. (See Rom. 8:34.)

Amen and amen! See you tomorrow.

The good life gets even better when you share it with friends! Join author Stormie Omartian and me as we talk about what it means to live prayerful. This is a bonus video streaming on the Lifeway On Demand app.

Day Two

THE ANSWER

Four things let us ever keep in mind: God hears prayer, God heeds prayer, God answers prayer, and God delivers by prayer.[9]

E. M. Bounds

Yesterday we heard the strong and tender voice of Amos as he prayed. He asked God to forgive and stop. We were left with a horde of locusts and an inferno. Cue the epic movie score. What would God do? How would He answer? Well, you already read it yesterday, so there's no spoiler alert here! Let's pick right back up with Amos 7:3,6.

Holy Spirit, be our Teacher today and lead us into truth. Protect Your Holy Word. Amen.

How did God answer Amos?

What was the word Amos used to describe God's response in Amos 7:3,6?

Refused *Relented* *Retreated* *Resented*

Amazing stuff going on here, sister. Amos interceded. God answered. God relented.

Your translation may use the word *repented*, which can be confusing since we usually connect repentance with sin, right? We need to better understand God's response to Amos's prayer, because, of course, God does not sin.

The original Hebrew for *repent* or *relent* has a variety of meanings, including to regret or feel sorrow or sympathy. It is also used to communicate the act of forbearance.[10] So, erase the modern understanding of the word *repent* from your mind because it isn't the best description of how God responded here. The best way to think of His response to Amos's prayer is that He relented or retracted His decision to punish tiny Jacob. (If you want to hear God's explanation in His own words of what it means for Him to relent, read Jer. 18:1-10.)

It's hard to understand how God could change His decision based on a mere mortal prayer. Did Amos really hold so much sway over God that he could make God stay His hand? That begs the question: Can God change His mind? What do you think?

Have you ever prayed and gotten a positive and quick response from God as Amos did? If so, describe it.

Gotta be honest, that hasn't been my frequent experience in prayer. If you haven't had an Amos-like quick and positive response to your prayers either, you may be feeling a little unsettled about now. Let's try to get an understanding of this.

What does Daniel 4:35 say about man's ability to influence God?

What does Matthew 7:8 say about the outcome of prayer?

What does Ephesians 1:11 suggest about God's will?

What does James 5:16 suggest about the power of your prayer?

God works out everything in conformity with His will. He does as He pleases and none of us can hold back God's hand. Yet our fervent prayers are powerful and effective, and all who ask, receive. *Whew!* Confused yet? I know, me too. Let's keep going.

WHAT DO THESE VERSES SAY IS TRUE ABOUT GOD AND HIS CHARACTER?	
NUMBERS 23:19	
PSALM 102:24-27	
ISAIAH 46:9-11	
MALACHI 3:6	

God remains the same, and His purpose will stand. What He plans, He will do. God is immutable, unchanging. He does not change His mind. So, if God doesn't change, if what He plans He will do, then how does our prayer fit in since Matthew 7 and James 5 tell us to pray because our prayers work? To me, this confusion and apparent contradiction get untangled in one word: *sovereignty.*

The sovereign God has incorporated the prayers and the choices of His people into the fabric of His sovereign plan. This includes individual prayers of Amos and you and me. In Amos, the sovereign Lord knew who would pray, who would repent, return, and who would rebel. Yet He graciously allowed Amos to be involved in His purpose.

GOD USES PRAYER AS A MEANS OF ACCOMPLISHING HIS PURPOSE.

It seems to me that if we really want to get a better grasp on this truth, we have to focus less on getting God to answer our way and focus more on getting our hearts to pray His way. Jesus taught us how in Matthew 6:9-13. We don't need to complicate that which Jesus made simple for us.

Pause here, put down your pen, and just pray. Pray the Lord's Prayer.

Lord, we do pray Your kingdom come and Your will be done on earth as it is in heaven. Amen.

We must also keep in mind the purpose of prayer. Check out the end of both John 14:14 and 16:24 to note that purpose.

_____ and _____

The dual purpose of prayer is that God is glorified and our joy is complete. Or, as John Piper put it, that "God is most glorified in us when we are most satisfied in Him."[11]

If the ultimate purpose of prayer is that God is glorified and we are satisfied in Him, then I figure my prayer should be an expression or extension of my life, not an exception to it. In other words, we must live like Amos—in constant dependent relationship with God. Amos communicated the words and thoughts of God because God communicated those thoughts and words to Amos. For us, we stay in God's Word so our prayer is based on God's thoughts and words.

WE DELIGHT IN GOD.

If you delight in the Lord, you can trust He will give you (place in you) the desire of your heart (Ps. 37:4). He will guide your prayers. Your prayer doesn't dictate or limit what God does; your prayer involves you in what God is doing.

God does answer prayer. He doesn't ignore your intercession. God's answer to Amos's prayer was driven by God's character. God's character doesn't change even when His approach does. Amos didn't "change God's mind." Amos appealed to the sovereign Lord's character and, in response, God revealed another aspect of His character—His forbearance.

My sister, intercede because God is good and God hears. You can trust the heart of God. He may honor you with a yes or humble you with a no, but you are guaranteed your sincere prayer of faith is part of His sovereign design and desire for you, His child.

From your viewpoint, it may appear that God relents. He may seem to change His mind. But no matter what, you don't stop, you don't relent. You seek the best answer from God—a change in you, a change in your will being conformed to His.

And all the sisters said, "Amen!"

I need some strong coffee after that. And I need to pray! Good stuff. See you tomorrow.

Day Three

SHOW US THE PLUMB LINE

God is the only Being who is good, and the standards are set by Him. Because God hates sin, He has to punish those guilty of sin. Maybe that's not an appealing standard. But to put it bluntly, when you get your own universe, you can make your own standards.[12]

Francis Chan

———————

Hey, my friend. I hope you're falling more and more in love with the God of Amos. I also hope you are interceding every day for the person you named on Day One of this week (p. 151). God hears, so keep praying.

We've looked at two visions in Amos this week. In both, we've heard Amos intercede and God relent. Now in this third vision, we'll see God's eventual answer to Amos's prayer didn't come from God's mouth; it fell from God's hand.

Before we read God's Word, pray Ephesians 1:18 over yourself, your study, and your Bible study buddies.

Lord, open our eyes today. Give us vision to see Your Word clearly. Amen.

TURN TO AMOS 7 AND READ VERSES 7-9.

Do you know what a plumb line is? If so, describe it below. If not, do a quick Google search or ask your nearest friendly carpenter and write what you discover.

A plumb line is a cord with a weight attached to one end. When you hold up the cord and let the weight dangle freely, it creates an exact vertical line. Handy people like carpenters use plumb lines to keep their work straight. A plumb line doesn't change or move with the whims of the carpenter. It follows one law, the law of gravity. If a plumb line isn't used as the standard, the walls could be tilted and the cabinets crooked.

The term *plumb line* shows up several times in the Bible. If you've got extra time, do a word search in your favorite Bible resource, or ask Google to find all the places *plumb line* shows up.

Let's look at a couple together.

READ ISAIAH 28:16-17. What does this imagery say about God, and what does the first part of verse 17 tell you about this kingdom He is building?

God is the Master Builder, and as God builds His kingdom, He will use a standard. His standard. He will ensure it is perfect. In other words, there won't be any crookedness there! It won't be built on errors and falsehoods. There will be no sin to bust up the perfect foundation.

Now, pop over to another prophet, Haggai. (I have a big crush on this one.) Yes, our guy Haggai. If you did the *Take Courage* Bible Study, you may have a crush on him too. Anyway, you may know that Haggai and another prophet, Zechariah, cheered on the discouraged Jews in their rebuilding of the temple after they returned from exile.

READ WHAT ZECHARIAH 4:10 SAYS BELOW.

For who has shown contempt for the day of small things? But these seven will rejoice when they see the plumb line in the hand of Zerubbabel—they are the eyes of the LORD roaming throughout the earth.

What could the use of "plumb line" be describing about the rebuilt temple?

God was encouraging His people that justice and righteousness would again exist. The standard of holiness that God, the Master Builder sets, would once again prevail.

BACK TO OUR NEW FAVORITE PROPHET, AMOS. PUT DOWN YOUR PEN AND READ AMOS 7:7-8 AGAIN.

Notice where God was standing and where God had positioned the plumb line. I know it's not easy because this is God we're talking about, but try to visualize God standing by a perfectly straight wall with a plumb line dangling from His hand. Now look again at verse 8. If you were Amos, how would you answer God?

If I heard God ask, "Jennifer, what do you see?" well, first, I would be conflicted because I'm blind! But I guess in a vision from God I would see 20/20! That is a whole other issue. Anyway, I think I would be so thorough in my answer. "Lord, I see You. I see a plumb line in your hand. I see a wall." And at that point, God would probably remind me to focus on the main thing! But, sister, really look at that in your mind's eye. The state of the wall matters because it reveals whether or not it was built by the proper standard.

I guess why this is important to me is because I can celebrate, promote, and even affirm God's standard. It does stand alone, and I agree with it. But when the "wall" of my life is compared to the plumb line of His standard, I have to confront what my wall looks like.

My sister, our lives can get crooked, crumbly. They may lean instead of standing upright. The state of the wall shows whether or not we've used the right standard to build it.

God was giving Amos a chance to see clearly to whom he was preaching. Israel was a crooked wall because she had rejected God's plumb line. The Israelites had spent their lives justifying their crookedness rather than straightening up and letting justice flow like a mighty stream. After two appeals from Amos and two gracious reconsiderations from God, it seemed God was saying, "Enough. There is a standard. I set it. I do not change my standard."

GOD'S MORAL LAW WAS THE PLUMB LINE FOR ISRAEL.

When Israel was measured against the holy standard of God, she came up short, and once again, the result was ruin.

READ AMOS 7:9.

What about us? John 17:17 shows us our plumb line. What is it and what does it do for us?

Truth is our plumb line. God's Word is true, and His truth sanctifies us.

A mere construction worker can't just come into a building project and tell the master carpenter, "Never mind. I don't need your plumb line, I brought my Silly String®. I will just squirt a bit, and I'm sure it will be close enough." Of course not. Because Silly String is not a plumb line.

The same applies to you and me when it comes to the standard of our lives. There is not my truth, your truth, your favorite author's truth, and your cousin's truth. There is not old truth or new truth. There is one Truth. One plumb line. God's Word.

Therefore, we pray, "Show us the plumb line." We need God's way, not our way. We need God's Truth, not our truth. We need God's plumb line, not our own Silly String. Otherwise, we will build our lives, and the result will be unstable, crooked, and weak, much like the Pharisee in the story Jesus told in Luke 18.

POUR A NICE CUP OF SOMETHING AND READ LUKE 18:9-14.
As you read, think about the standard each man used to build his life.

How would you describe the standard the Pharisee used? The KJV translation says, "The Pharisee stood and prayed thus *with himself* . . ." (v. 11, emphasis added). I love that! It was like he was a church of one. Praying with himself makes me wonder if he was praying to God at all. He was measuring himself against himself. The standard was his work and all the sinners he could list. His righteousness made him feel pretty upright.

How would you describe the standard the tax collector used? With downcast eyes, it was as if the tax collector saw the righteous God with a plumb line in His hand. He saw the righteous standard, and he saw the crumbly, crooked wall that was his own life, and he knew he did not measure up.

God stands on our puny wall of self-righteousness and our own justification and graciously drops the plumb line, exposing our crookedness, our deep need. Our response to that standard should be like that of the tax collector: "Have mercy on me, a sinner!" (v. 13, CSB).

How did Jesus describe the state of the tax collector when he went home?

Jesus said the tax collector went down to his house *justified*. The Pharisee? Not so much!

Do you know what the word *justified* actually means? To be justified means to be made upright, made vertical, or to be made right with God. I. Love. That.

The vision of the plumb line prompts us to align our hearts with God's standard.

Oh, Lord, may our actions measure up to Your principles. May Your Word be our truth, the only truth we build our lives on.

Let's finish today by praying Psalm 86:11. Find several translations of this verse and use them to write your plumb line prayer.

If you need to know what to say when you just don't know how to pray, listen to the conversation with Sheila Walsh on the *4:13 Podcast*. Also, there's a song by Coldwater Jane that just may be the soundtrack you need for prayer this week. Go to 413podcast.com/89 to listen.

4:13 Podcast, episode 89

Lord, You are the Rock. Your works are perfect and all Your ways are just. You are a faithful God who does no wrong. Upright and just are You. May we reflect Your life and character. In Jesus's name, Amen. (See Deut. 32:4.)

I'm grateful for this truth, and I'm grateful for you. See you tomorrow!

Day Four

THE REWIND FORWARD

Every happening, great and small . . . is a parable whereby God speaks to us; and the art of life is to get the message.[13]

Malcolm Muggeridge

Brace yourself. We're going back to the eighties again. Don't worry though—you don't have to wear shoulder pads the size of an NFL linebacker. But feel free to listen to a little Amy Grant and Michael W. Smith just to get in the mood!

> **Here we go. What if you could jump into a shiny DeLorean®**
> **like Marty McFly and transport back to your teen years? What**
> **would you say to your younger self? How might your younger**
> **self respond differently to God and His Word based on what**
> **your right-now self knows?**

Then, once you downloaded all your right-now, hard-earned wisdom to your younger, thinner, yet oh-so-much-dumber self, you could come back to the future, and maybe some things in your life would be a little different. Maybe you would have avoided some of the lessons you learned the hard way. *Hmm.*

Well, there is no magic DeLorean. And, thankfully, all the things we didn't know or do in our past have been used and redeemed by God to make us who we are, so we're all good. We don't need a rearview mirror full of regret. But I ask you those questions to prep you for our study today. In a sense, we're going to go back to Israel's future. We're going to unpack a psalm of communal prayer from Israel over forty years after the time of Amos's prophecies. This will show us the result of Israel's lack of prayer.

Lord, thank You for Your Word. May we take it in, may it be our nourishment and the joy and delight of our hearts today. Amen. (See Jer. 15:16.)

TO SET THE STAGE, READ AMOS 4:3-12.

What was the big point God was making to His people in these hard verses?

Over the centuries God allowed or sent storms and plagues and droughts and all sorts of bad stuff to try and get the Israelites' attention. But no matter what came, Israel did not return to Him.

Around the same time Amos was making this point, what was Hosea urging Israel to do in Hosea 14:2?

Hosea called Israel to pray for forgiveness and restoration. "Forgive all our sins and receive us graciously, that we may offer the fruit of our lips" (Hos. 14:2b, NIV).

A SIMPLE PRAYER FOR FORGIVENESS CAN USHER IN THE GOOD LIFE.

Remember earlier this week we saw that Amos had asked God to forgive Israel (Amos 7:2)? But did you notice the Israelites never asked for themselves? They never prayed for forgiveness.

When we live faithful and prayerful, we will be sensitive to God calling us to Himself or back to Himself through the voice of His Word, His Spirit, or through hard circumstances. But when we are full of pride instead of prayer, we miss out on hearing God's voice—even when He speaks through loss, hunger, and storms.

God longed for Israel to return to Him, yet the Israelites would not repent. They could have prayed for mercy. They could have prayed for forgiveness. They could have returned. But the prayer they didn't pray in Amos's time likely prompted what they prayed in Psalm 80.

Flip back in your Bible (but forward in time) and read this prayer of Israel. But before you read the psalm, heads up. Scholars aren't one hundred percent sure of the circumstances that prompted the prayer of Psalm 80. However, references to Joseph, Ephraim, and Manasseh suggest that this was a Northern Israel psalm. So this likely could be Israel's prayer as she suffered under Assyria in the late eighth century. (Assyria captured Israel and destroyed the Northern Kingdom in 722 BC as Amos predicted.)[14]

SINCE IT SEEMS SAFE TO ASSUME THAT CONTEXT, READ PSALM 80 as if you're hearing the prayers from the Israelites who were exiled by the Assyrians. Put down your pen—don't try to take notes. Just read the whole psalm.

All right. Now that you've heard their ancient voices, what words would you use to describe this psalm?

The Israelites were chosen, the vine God planted and tended to. Yet their words have a desperate echo, don't they? I hear longing and regret.

Maybe you recognize their ancient voices because it sounds like yours when you pray. You long for God to restore. You need Him to make His face shine upon you. You long for God to save you from what you are dealing with. Sister, we've seen in God's Word that He does hear you. You are His chosen daughter, so keep trusting the sovereign God of Amos. Keep living prayerful, because if you feel like He is all you've got, you are in the best place ever. I promise you He is all you need.

I want us to see the shadows of Amos in Psalm 80. Let's look at what Israel's present state was in Amos, at the same time we see what would be her future in Psalm 80.

First, how did Israel address God in Psalm 80:1?

What does the word *shepherd* say about the Israelites' relationship or appeal to God?

Like a good shepherd, God was the caregiver and protector for Israel. Yet He was a shepherd King because Israel knew He sat "enthroned between the cherubim" (NIV).

How did Hosea describe this shepherd relationship between God and Israel in Hosea 4:16?

Did Psalm 80:4 trouble you when you read it? It appears on the surface that God was frustrated and annoyed by Israel's prayers. But the Hebrew word for angry is *ashan,* (or *ashantah*) and it literally means "to smoke."[15] Scholars say the expression here is unusual, and an accepted translation of this verse is: *How long will you be angry during your people's prayers?* It seems this is referring to length of time, not the content of prayer.[16] So, pray, sister!

"You, LORD, hear the desire of the afflicted . . . and you listen to their cry" (Ps. 10:17, NIV).

Israel didn't live like the Lord was her Shepherd. Instead, the Israelites didn't return; they rebelled like stubborn calves.

So back to the future. What was Israel asking in Psalm 80:1-2?

Israel was begging God to hear her prayers and step in. Think of Amos's messages. What was God, through Amos, asking Israel to do? (See Amos 3:1.)

God was pleading with Israel, through Amos, to hear His words. But the Israelites did not listen. How often do we do that? How often do we fail to listen to Him when He speaks?

Oh, Lord, soften our hearts and forgive us. We want to hear Your voice and obey Your Word. Amen.

BACK TO PSALM 80. What do verses 3, 7, and 19 have in common?

This is the refrain of the song, the main point of their plea. *Restore us; show us Your favor so that we may be saved.* Israel was in full prayer mode, right? Yet this prayer could have remained unprayed if the Israelites had accepted God's invitations so many years earlier to live faithful, live humble, and live justly. Put simply, they wouldn't be asking for restoration in Psalm 80 if they had chosen repentance in Amos!

Think about your life. Is there something you're choosing right now that you'll regret later? Are you planting seeds of sin right now that later will blossom into a bitter harvest? Pause and ask God to examine your heart. If sin is hanging out there, repent and be restored. Stay here until you sense a green light from the Lord on this.

Back to the Israelites' future and a bit of their past. Compare Amos 6:6 to Psalm 80:5.

They drink wine by the bowlful and anoint themselves with the finest oils but do not grieve over the ruin of Joseph.
Amos 6:6 (CSB)

You have fed them with the bread of tears; you have made them drink tears by the bowlful.
Psalm 80:5 (NIV)

How do the bowls in Psalm 80 strike you after reading about the bowls in Amos?

In the future, the Israelites would be crying bowls full of tears. Yet back in Amos's day, they were gulping bowls full of wine. If you were an ancient Israelite praying Psalm 80 under possible Assyrian oppression and you could speed back in time in a DeLorean, what would you say to your younger self who was listening to Amos?

I would preach Psalm 126:5-6 to my younger self. "Jennifer, if you sow tears now, if you live humbly and repentant, then, girl, you will abound with joy."

We need to think about what we would say to our younger selves because we are our younger selves! Yep, right this minute, this is the youngest you will ever be! So, practice now what you would preach to yourself later. It will help you live the good life.

Moving on. In Psalm 80:6, how did the Israelites describe how they felt and were treated?

How does Amos 2:6-7 describe how the Israelites treated those with less privilege than they?

Oh, sister, isn't this interesting? In Amos's day, Israel mistreated and made light of the poor and oppressed. Yet in their future, the Israelites would be the ones who were treated with derision. This example makes me approach Galatians 6:7 very thoughtfully, right? *Whew.*

Moving on in our Bible time travel. In verses 8 through 11 of Psalm 80, you get a poetic picture of the truth in Amos 3:1-2. Israel was chosen. They were like a fruitful vine God had grown and tended.

BUT THEN, SISTER, LOOK AT PSALM 80:12 AND THEN READ AMOS 7:7. Considering what we learned yesterday about God standing by the "wall," how do these passages and this image speak to you?

I just can't help but see God standing by the wall with the plumb line. And then I see these exiled Israelites praying for restoration and I think, The wall would not be broken down if it had adhered to the plumb line.

Oh, we can learn so much from the Israelites' choices—like what we learn from their choice to be prayerless. Sure, they did their religious things. They didn't miss a sacrifice, ceremony, or festival, but their hearts missed the whole point. They missed out on the relationship with God that is developed and deepened by prayer.

I don't want to miss the point, and I know you don't want to either. So, let's pray like the Israelites in Psalm 80:18-19. Rewrite those two verses using your own words and first-person singular pronouns.

Dear God,

Amen.

Well, my friend, our study of Invitation Six is a wrap! Tomorrow will be our Good Life Day when we ponder and practice what we've learned.

May we accept God's invitation to live prayerful. May we intercede like Amos. May we focus our prayer on what God cares about and feel His care for us. May we trust His sovereignty and accept His answers to our prayers. May our lives seek, gravitate to, and line up with His holy and good standard.

Amen and amen! Thanks for being faithful to God's Word and your Bible study buddies.

Love,

Jennifer

Day Five

YOUR GOOD LIFE DAY

Lord, I receive Your invitation to live prayerful.

Where did the message meet me this week?

☐ I want to make intercession a daily habit.

☐ I seek to grow in my trust that God is sovereign when it comes to answered prayer.

☐ I need to line up my standards more closely with God's.

☐ I want to become more aware of my daily choices and willingness to repent.

What would my relationship with God be like if I prayed consistently?

What is one practical way I can incorporate prayer into my lifestyle?

When will I schedule time to pray this week?

This week, God taught me . . .

MY GOOD LIFE DECLARATION

To live the good life, I will live the God life and . . .

I will let go of:

I will trust God with:

I will take hold of:

To make your Good Life Day even better, listen to my #GoodLife playlist at jenniferrothschild.com/amos.

INVITATION SIX:
Live Prayerful

BEFORE THE VIDEO
Welcome and Prayer

VIDEO NOTES

To access the video teaching sessions, use the instructions in the back of your Bible study book.

THREE ELEMENTS OF HOW TO PRAY LIKE AMOS:

1. Women who pray like Amos confirm God's _____.

 There is a difference between God's _____ and

 God's _____.

 We want what our Master _____ for us, not necessarily what we

 _____ for ourselves.

2. Women who pray like Amos cry out for _____.

 We deserve _____ from God.

3. Women who pray like Amos _____ their _____

 and _____.

If you want to review what you just experienced, go to jenniferrothschild.com/amos to get a written summary of this video message.

CONVERSATION GUIDE

DAY ONE: How would you explain the sovereignty of God? Why is this aspect of God's character so important? How has God's sovereignty been evident in your life? What does it mean to intercede for someone? For whom do you need to be interceding right now?

DAY TWO: When God answers your prayers, does it usually happen quickly, or does it take a while for Him to respond? Give an example of each. What's the last prayer you prayed that God answered? Do you consider your prayers to be powerful and effective? Why or why not?

DAY THREE: If you were to measure your life right now against the plumb line of God's Word, how straight would you be? In what areas of your life would it show crookedness? In the parable mentioned in the Day Three study, who are you more like—the Pharisee or the tax collector? Explain.

DAY FOUR: How does living prayerful open the eyes and ears of your heart? Are you making some choices right now that you possibly will regret in the days to come? Explain. What will it take for you to make different choices?

VIDEO: What's the difference in praying for God to act in His power and praying for God to act according to His authority? How does acknowledging we have needs help us be spiritually healthy? What is something God taught you this week? Why is it so important that you accept God's invitation to live prayerful?

INVITATION SEVEN

YOU ARE INVITED TO

Live Hopeful

Day One

NO NEED TO HIDE

If the Lord be with us, we have no cause of fear. His eye is upon us, his arm over us, his ear open to our prayer; his grace sufficient, his promise unchangeable.[1]

John Newton

We've made it to the last chapter of Amos and our last week of study together. It's been so, so good to make Amos famous with you. We've accepted six invitations so far: Live Assured, Live Faithful, Live Chosen, Live Humble, Live Justly, and Live Prayerful. And now, Live Hopeful.

There is no good life without hope. And there is no hope without God. In the midst of ruin, rebellion, and its sad ramifications, there is still a greater hope that holds us and helps us hold on. That hope is not a wishful thought. It is a confident expectation rooted in the character of God and in the cross of His Son, Jesus.

OPEN YOUR BIBLE TO AMOS 9 and open your heart to all God has for you, my friend.

Lord, we are so thankful for Your Word and all You have taught us. Find us faithful to be doers of Your Word, not just hearers. For Your glory, Lord. Amen.

Before you read the Scripture, come back to eighth-grade summer camp with me.

Every July, when I was a kid, our family of five smooshed into our tiny Ford Fairmont and traveled from Miami, Florida, to Black Mountain, North Carolina, so my dad could teach a few weeks at Ridgecrest Conference Center. That meant my brothers and I spent almost a month in the dreamy Appalachian mountains. We pulled into Ridgecrest that particular sticky summer day later than usual. So instead of my brothers and me helping to unload the car, we went straight up the mountain because camp had already begun and we were late for recreation. When we got there, counselors sent us to our assigned Bible study group, and the competition began. The game was "people passing." Each team of forty students lined up face to face, twenty on one side, twenty on the other. The students extended their hands toward each other, palms up, so they were touching fingertip to fingertip, creating an elongated net

of human arms and hands. The goal was for each team to pick the lightest person on the team to lie facing up on one end of this human net, and then at the word *Go*, shuffle that lucky little human down a conveyor belt of tangled limbs at lightning speed. The team who got their person to the end first won. Sounds fun for teenagers, right?

Anyway, guess who was the smallest girl on my team? Yep, me. And guess who also had not shaved her legs in a whole week because she was smooshed in the back seat of a Ford Fairmont with her brothers? Yep, me. So, since we're friends now after six weeks together, I can be honest about my hairy legs. My hair is thick. My hair is coarse. Imagine a cross between a horse and a sheep needing shorn. On my head, it's fabulous. On my legs? Not so much. Since that was the case, my mom let me start shaving my legs that summer. But you know how it is. Once you start, you better not stop! Because my hairy legs had been shorn every few days and then totally neglected, the stubble protruding from my skinny legs by the time I got to North Carolina was weapon-grade shards. But I was too inexperienced to realize what was about to happen. I climbed up on the first set of arms, facing that broad expanse of North Carolina sky, and someone yelled, "Go!"

What followed was teenage voice after teenage voice groaning in horror. One after another they exclaimed and gasped, "Don't you ever shave your legs?" "What is all over your legs?" "Ouch!" "Gross!" "Shave your legs!" "Oh my gosh, your hair is so thick."

I will give you a minute to process that teenage trauma.

Awful, right? Oh. My. Goodness. Can I just say, I have never wanted to hide so badly in my whole, entire life. I wanted to run as fast as I could from that group of teens and hole up in my cabin with a package of razors and shave, shave, shave. But I couldn't run. I couldn't hide. There was no refuge from that embarrassment. I was entrenched in that tangle of hands until the race ended. And when it did, I was stuck on the mountain in hairy-legged humiliation.

> **NOW READ AMOS 9:1-4. It won't sound super hopeful on the surface, but as we dig underneath these words, you will find seeds of hope.**
>
> **Using just adjectives, describe this vision:**

Here are mine: *Bleak. Destructive. Despair. Hopeless. Futile. Merciless.*

Not very hopeful, huh?

This awful final vision of Amos is a dark and dramatic way to illustrate that the Israelites could run,

but they couldn't hide. It showed God's incredible power and Israel's utter ruin. Sister, I know those were hard words to read, hard pictures to see, hard feelings to feel. Amos used his linguistic flourish to communicate there was no escape for Israel.

We may shake our judgmental heads at the Israelites for their rebellion and sin. But if we shake our heads at Israel, we better be looking in the mirror when we do it! Yet, in Christ, we are spared from every condemnation.

THOUGH ISRAEL WOULD FIND NO PLACE TO HIDE, READ WHAT COLOSSIANS 3:3 SAYS ABOUT YOU. Rephrase it into a first-person statement about yourself.

In Christ, we need not hide because we are already hidden in Him. In Christ, we are spared from humiliation because He humbled Himself on our behalf. We need not fear God's wrath because Jesus bore it for us. We need not live without hope because He is our living Hope. Sister, because of Jesus you are hidden with Christ in God.

Let's look back at this vision in Amos from this side of the cross and see the hope we have in Christ. In the list below, jot down next to the Amos references how each offers a message of despair. Then read Psalm 139:5-12. As you read these clearly hopeful Scriptures, jot down how each of them offers a message of hope.

DESPAIR		HOPE	
AMOS 9:2a		PSALM 139:8b	
AMOS 9:2b		PSALM 139:8a	
AMOS 9:3		PSALM 139:9-10	
AMOS 9:4		PSALM 139:11-12	

Beautiful, right? The darkness of Amos's final vision bursts into brilliant hope in light of Psalm 139.

God hems you in, my sister. He lays His Hand of assurance upon you. You never need to hide from Him because you are hidden in Him. There is nowhere you can go from God's Spirit because He is with you. Such knowledge is just too wonderful for us, isn't it?

Pause here and ponder this truth. Spend some time thanking God for His just and merciful character expressed on the cross through Christ.

Use some or all of the passages listed to create a prayer of declaration that you are safe in the shelter of God:

> Psalm 9:9 • Psalm 18:30 • Psalm 34:22 • Psalm 37:3 • Psalm 46:1
> Psalm 91:4 • Psalm 119:114 • Proverbs 30:5 • Nahum 1:7

Lord, You are good. You are our safe place when we want to run and hide. You know, You see, and You care for us. We run to the refuge of Your heart. Your Word is true and Your character is our shelter. We put our whole trust in You. Amen. (See Prov. 30:5; Nah. 1:7.)

All right, let's finish up today with this one last passage: Hebrews 6:18-19. Read it in several translations and then explain what God is saying in your own words.

When this letter to the Hebrews was read centuries after Amos, those believers would have probably understood exactly what the writer meant by "two unchangeable things." They knew that because God's power and character were reliable and true, God's promise and oath were both sure. God would not, could not, go back on His word. History had proven it. So, because all that is true, they found deep encouragement in the work of Christ on the cross to bring them to God. And so can we. Jesus has taken us behind the curtain that separated us from God. He is our hope. He is our city of refuge, the place we run to escape death and condemnation.

Oh, my friend, every prophet points to Jesus. Every book of the Bible features Jesus. Every word in Scripture is about Jesus. And it is to Him you flee. You run with your very life to take hold of the hope that is in Him—the hope that *is* Him! And in that hope, in that hiding place is the encouragement your soul needs.

My hope is built on nothing less than Jesus' blood and righteousness; I dare not trust the sweetest frame, but wholly lean on Jesus' name.[2]

Day Two

CLING TO THE *NEVERTHELESS*

There is no Christian Gospel if history simply unwinds into a meaningless puddle, if the cosmos simply escapes into a cataclysmic black hole, or if the universe finally dies of exhausted energy. Without belief in a Biblical eschatology, there is no Christian hope. Without a sense of perfect moral judgment in the end, the human heart is homeless.[3]

Albert Mohler

I'm sitting at my desk with a Mission Fig candle flickering beside me. My friend, Paula, gave it to me as a sweet Amos reminder and an affirmation that I am on "Mission Fig"! And, sister, you are too! We are on mission to know and grow all we can as we learn from God through our favorite fig farmer, Amos. So, light a candle while you study today. As you do, enjoy the beauty of the flame and breathe in the fragrance of hope.

Today we'll be in Amos 9:5-10. In this passage, Amos followed the dark picture from yesterday with the brilliance of God's power in a doxology. Before we read it, let me invite you to speak or sing the "Doxology" I used to sing in church. Use it as a prayer today.

Praise God, from whom all blessings flow;

Praise Him, all creatures here below;

Praise Him above, ye heav'nly host;

Praise Father, Son, and Holy Ghost.

Amen.[4]

Did you sing it? I did. To me, there's just something that stills you, quiets you, and focuses you when you sing truth.

ALL RIGHT, SISTER, NOW READ THE DOXOLOGY IN AMOS 9:5-6. After you read it, pause and once again either read or sing the doxology above.

We do praise You, Lord. You are the Lord God of Hosts.

"Lord GOD of Hosts" is how Amos opened this doxology in Amos 9 (ESV). Your Bible translation may read "Lord GOD of Armies" (NASB) or "LORD Almighty" (NIV). The literal translation is "My Master Yahweh." Amos used the title Lord GOD twelve times in Amos 7-9.[5] It emphasizes that God is sovereign. Just like we learned that we can live prayerful as we trust our sovereign God to answer, we can live hopeful because God is sovereign over all.

How would you describe God based on the imagery in Amos 9:5-6?

To me, Amos depicted God as powerful, intentional, creative, and Master over the whole earth.

"What counts is that God's presence is at home everywhere in the universe from top to bottom, and that presence is utterly dependable and permanently to be reckoned with . . ."[6]

This doxology was not just a bit of pretty poetry on Amos's part. It had the distinct purpose of showing God's immense power, reminding Israel, "This is your God." Seeing God's beauty and sovereignty, through the artistry of words, was to prompt them to act according to God's glory and authority. Amos, like other prophets, was constantly revealing who God is, because knowing who your God is impacts how you live.

That's why, sister, maybe we need to speak or sing the "Doxology" a little more often. Or perhaps, along with reading the beauty of Scripture, you need to read poetry about God or sing other lyrics that extol His power and majesty. These kinds of words remind us He is worthy of our praise. It is from Him that both judgment and blessing flow. Every creature praises Him. He has given us His Spirit. He has saved us through His Son, and He has been our God. Worthy. Worthy. Worthy.

The LORD is His name.
Amos 9:6b

NOW READ AMOS 9:7-8. Do you know the nations and peoples named in verse 7? It's OK if you don't. But think about whom they could be based on God comparing Israel to them. What point do you think God was making?

These words from God are like great equalizers! To Israel, the Cushites ("the sons of Ethiopia") were as nothing—distant, insignificant people. Especially when the Israelites compared the Cushites to themselves. God had chosen the Israelites, and He had even brought them out of Egypt, right? They were special. But then, uh, wait—the Israelites heard that God also was in charge of moving two of their enemies, the Philistines and the Syrians. Just like in Amos's doxology, this soliloquy shimmered with God's sovereignty.

> **PAUSE AND JUMP OVER TO THE NEW TESTAMENT. READ COLOSSIANS 1:15-22 and linger there, praising God for His sovereignty over all creation revealed in Jesus.**

Sister, when you are low on hope, you need to see how high your God is. He is bigger than your problems. He is above what tries to pull you down. He is more powerful than your fear, mightier than your adversary, and greater than your imagination can fathom. There is nothing, not one thing, that happens in this world or in your world that is a slipup or an oversight to sovereign God. So, keep right-sizing God through worship. It will right-size you and what you face and help you live hopeful.

God, through Amos, was once again reminding the Israelites they were sinful—no better than those nations they looked at down their pious noses. Yet Israel belonged to God.

> **According to Deuteronomy 7:6, how is Israel described?**

> **From a treasured possession to a sinful nation. _Ugh_. And according to Amos 9:9, what would the result be?**

It's super interesting that forty years after this prophecy, Assyria came in and "shook" up Israel. And in many ways, the Assyrians were used by God to sift Israel. Assyria had her own brand of "shake and bake" when it came to warfare. The Assyrians would show up, conquer a nation, and then force most of the citizens out. They'd haul them off to other parts of Assyria's empire. Then they'd send some of their own Assyrians to relocate in the conquered territory. It was a grand dispersion designed to strip national identity and make a conquered nation disappear. So what Amos predicted here makes sense; the "House of Israel" was sifted among the nations. But all was not lost. Israel was given a promise even in this.

> **READ AMOS 9:8-9 AGAIN. What hopeful promises do you find here for Israel?**

A remnant would survive. God said He would "not totally destroy the house of Jacob" (v. 8, CSB). And when God shook the nation of Israel "as one shakes a sieve" (v. 9, CSB), the good grain would fall through and remain while the "pebble[s]," the wicked, would be destroyed.[7]

Likely some in the crowd hearing this last sermon from Amos were pretty chafed by his message. It rubbed them the wrong way for sure.

READ AMOS 9:10.

They were convinced they were safe from judgment, saying, "That'll never happen to us." Yet as Flannery O'Connor said, "The truth does not change according to our ability to stomach it emotionally."[8] Disaster was not inevitable for Israel; it was invited by Israel. That is a hard reality. But it does reveal hope because hope reminds us we don't have to choose pride. We don't have to choose disaster. We don't have to live in denial. Sister, we do not live without hope because of Jesus. He is "the way, and the truth, and the life" (John 14:6).

> There is one big hope word in our verses today, found smack dab in the middle of Amos 9:8. Read the verse below. Figure out what the word is, circle it, and write the definition. (Hint: It starts with the letter N, and it has four syllables.)

"Behold, the eyes of the Lord GOD are on the sinful kingdom,
And I will eliminate it from the face of the earth;
Nevertheless, I will not totally eliminate the house of Jacob,"
Declares the LORD.
Amos 9:8

Definition:

If you need a little hope, listen to episode 6 of the *4:13 Podcast.* Plus, you can download "3 Confessions to Hang Your Hope On When You're Disappointed." Listen anytime at 413podcast.com/06

4:13 Podcast, episode 6

Nevertheless. I love that word! *Nevertheless* is a word of hope.

God was assuring His people there would be a remnant. The Northern Kingdom of Israel would be destroyed, but the house of Israel, His people, His whole family, the twelve tribes, would never be utterly destroyed. God was giving the big "nevertheless"!

Though you sin . . . nevertheless.

Though you fail . . . nevertheless.

Though you wander . . . nevertheless.

Though you disobey . . . nevertheless.

Nevertheless means "in spite of," "yet," "nonetheless," or "however." Jesus is our "Nevertheless."

Jesus stepped right into our sin-stained world, and His very life was the "nevertheless."

It reminds me of another set of words in Scripture that bring me hope: *but God.* And that is where we need to end today, with the *nevertheless,* with the *but God.*

> **Look how God inserts Himself, His "nevertheless," in the midst of the circumstances in your life. Beside each reference, paraphrase what comes before the "but God" in each verse, and then what comes after.**
>
> Genesis 50:20 _____
>
> *BUT GOD* _____
>
>
> Psalm 73:26 _____
>
> *BUT GOD* _____
>
>
> 1 Corinthians 1:26-29 _____
>
> *BUT GOD* _____

2 Corinthians 7:5-7 _____

BUT GOD _____

Ephesians 2:1-5 _____

BUT GOD _____

Lord of Hosts, Thank You for giving us hope. Thank You for Your sovereignty. Thank You for holding us secure even when we feel shaken. Thank You for Jesus, our "Nevertheless." Thank You that You are our hope. May we live in praise of this unspeakable gift. Amen.

All right, sister, though there is much more we could plumb today, nevertheless, it's time to blow out the candle, close the book, and open our lives to live what we have learned!

See you tomorrow.

Day Three

GOD WILL RAISE
UP THE RUINS

The church is not a select circle of the immaculate, but a home where the outcast may come in. It is not a palace, with gate attendants and challenging sentinels along the entrance-ways, holding off at arms-length the stranger; but rather a hospital, where the broken-hearted may be healed, and where all the weary and troubled may find rest and take counsel together.[9]

John Hill Aughey

Put on your shades, my friend. It's about to get really bright in Amos 9 today. Hope is bursting on the scene! Finally, Israel can see clearly that Amos's messages have never been about revenge; they've been leading to restoration. All the rebuke has been for the purpose of revealing hope. All the calamity of the last eight chapters falls into place as the restored order God intended is revealed.

READ AMOS 9:10-12.

The tone change between verses 10 and 11 feels pretty abrupt. But that's how it is sometimes with hope, right? It's like a jack-in-the-box that you wind and wind, wait and wonder, but nothing happens. What a waste. And just when you think this thing is broken . . . *pop!* Hope springs up. The reason hope can burst in like a jack-in-the-box is because it was there all along. It doesn't just suddenly materialize. It's just fully revealed.

READ PSALM 33:20-22. Pray it as we get started.

Lord, we put our hope in You. You are our help and our shield. Our hearts rejoice in You because You are totally trustworthy. Teach us Your hope today. Amen.

Let's see the anatomy of this hope.

According to Amos 9:11, when did this hope take center stage?

One day Someday On that day Monday

Monday would be just fine with me! How about you? (Grin.) What did God mean by "On that day"? What day is that day? Do you remember Amos referring to "the day of the Lᴏʀᴅ" earlier in his sermons (Amos 5:18)?

LOOK BACK AT AMOS 5:18. Jot down what kind of day this will be.

This phrase, "day of the Lᴏʀᴅ," is also referred to as "that day" and refers to events that will take place when God intervenes in history to finally accomplish His plan or fulfill His promise. Now, sister, this is a big hairy subject that we just don't have time to totally deal with, so I'll give you a quick (and incomplete) summary—like what I'd tell you if we were in an elevator together (and there were only two floors and the elevator was really fast!). Some Bible smarties say this day can have both historic and future implications—historic in that it can refer to temporal judgments brought on disobedient nations, including Judah and Israel.[10] But mainly the "day of the Lᴏʀᴅ" has future implications. Some say it refers to a long period of time when Jesus will rule over the whole world, ushering in His kingdom.[11] Other scholars believe the "day of the Lᴏʀᴅ" will be a quick moment when Christ returns to get His faithful believers.[12] And those who don't believe? Well, as Amos put it, "[That day] will be darkness and not light" (v. 18).

(You can read more about the "day of the Lᴏʀᴅ" in this sampling of Scriptures: Isa. 13:1-11; Zeph. 1:14-18; Acts 2:20; 2 Peter 3:10; Rev. 6:15-17.)

Here's the thing: whether the future "day of the Lᴏʀᴅ" lasts ten seconds or a thousand years, the ultimate purpose and result of that day are summarized in Isaiah 2:17. What is it?

The purpose of "that day" is that all humans will be appropriately humbled, and God will be rightly glorified. Oh, sister, if that's the purpose of "that day," then it should be the purpose of this day, every day, all days we live, right? So instead of getting totally wrapped up in a study of eschatology (doctrine of the last days), get caught up in a broad study of our God, His glory, and His just and merciful character. May it result in humility and praise. We don't know the details of the last days. Girl, we don't even know what this day holds! But we do know our God holds us, holds history, and holds this whole thing together.

FIND HEBREWS 1:3 IN SEVERAL TRANSLATIONS and write it into a prayer declaration of certainty.

Jesus is the glory of God. Jesus shows us the nature of God because Jesus is God. By His mighty and powerful Word, He holds this whole universe together. And He holds your future. He holds it all together, sister. How "that day" will affect you has everything to do with whose you are. For some, that day will be the worst day. But if you are in Christ, that day will be a day of hope.

LOOK AGAIN AT AMOS 9:11. Write down words and phrases that depict hope to you.

Raise up the fallen. Repair its gaps. Rebuild its ruins. Those are phrases of hope because they picture restoration and renewal.

What or whom was Amos referring to here?

Amos told us the tabernacle (or "booth," "shelter") of David will be rebuilt "as in the days of old." Remember back in 930 BC, the Northern Kingdom of Israel split off from the "House of David" and rejected its royal line. Yet, here at the end of Amos, on "that day" God will restore the complete authority of David's line to rule and reign.[13]

How does 2 Samuel 7:1-16 communicate this promise about David's house?

David and his descendants were to build a "house," an actual temple (v. 13), but "house" also means the line of Davidic descendants (v. 16). Amos, along with all Israel, looked for the day when a Messiah would be raised up from the house of David who would rule and reign.

READ ISAIAH 11:1 AND JEREMIAH 23:5-6. NOW READ MATTHEW 1:1 AND LUKE 1:32-33.

The fulfillment of this promise is in Messiah Jesus. Jesus, the "Son of David," is our Messiah who restores all humanity to God. Hallelujah, what a Savior!

OK, let's slip away from the "day of the LORD" for a sec and pop back to a particular day in the first century. We know it as the council in Jerusalem.

READ ACTS 15:1-21.

Did anything you read remind you of Amos 9? If so, what was it? (Hint: Take a look in particular at what James said in Acts 15:13-21. He may have mentioned something you are familiar with.)

Yep, James quoted Amos 9:11-12. What point do you think James was making?

Some of the Jewish Christians insisted that Gentile converts had to be circumcised and follow Jewish law to be Christians. But Peter, Paul, and Barnabas disputed that claim, sharing what God had been doing in the midst of the Gentiles to bring them to faith. Then James recited this passage in Amos to confirm that God had put this promise to bring in the Gentiles in motion long before that council met. Amos was the first prophet to make known that God would bring Gentiles into His kingdom through the Messiah. This shook up the early church, which was made up of Jews. And, quite honestly, it should shake us up too. To think that God in His grace would graft us into His family is astounding (Eph. 2:11-20).

> **READ EPHESIANS 3:1-6. List the three ways Paul described Gentile Christians.**
>
> 1.
>
> 2.
>
> 3.

Paul was saying this mystery is mind-blowing! The Gentiles are fellow heirs, members of the same body, and partakers of the promise in Jesus through the gospel. Sister, he was talking about us, who we are, and what we have received. That means way back in Amos's day, you were on God's mind. He was making a way for you through Christ.

Even then, He was planning to repair what sin had destroyed. Even then, He was building a sure foundation through the tested, precious Cornerstone who is Christ. That means that even if today you find yourself amidst the ruin of disappointment, you have hope because you have Christ. If your life is broken and your heart is fractured by loss or pain, you have hope because you have Jesus. If sin has been your downfall, you have hope because Christ lifts up your life from the ruin of sin. God can raise up the ruins in your life and repair the broken places. Just as God promised to raise up from the ruin of Israel's sin a restored people, God can and will do the same for you, my friend.

John Piper said this about this passage in Amos: "Specifically, let it be an encouragement in your own life when you still feel very much ruined and fallen and broken down like a booth in the wilderness. Preach to yourself from this text that today is a day of repair and a day of rebuilding. God's will, revealed in prophetic Scripture and reaffirmed in the apostolic word, is that we not languish in ruin and disrepair. He is eager to rebuild the ruins of your life."[14]

As you finish up today, just lay down your pen, take a deep breath, and read the following Scripture. Put yourself in the crowd you will read about. Imagine Amos there with you on that day. The group described are the repaired, restored people whom God raised up from the ruin of sin. We are all there, from every nation and tribe, because of Jesus, our Messiah. As you read, thank Jesus for making you an heir to the promise.

After this I looked, and there before me was a great multitude that no one could count, from every nation, tribe, people and language, standing before the throne and before the Lamb. They were wearing white robes and were holding palm branches in their hands. And they cried out in a loud voice: "Salvation belongs to our God, who sits on the throne, and to the Lamb."
Revelation 7:9-10 (NIV)

Oh, there are just no words.

Thank You, Jesus.

Day Four

A DAY IS COMING

We are not to think, if God withholds the dew, that we are to withhold the plough. We are not to imagine that, if unfruitful seasons come, we are therefore to cease from sowing our seed. Our business is with act, not with result.[15]

C. H. Spurgeon

We gathered around the brand-new piano in the little Stone Mountain Church. I was nestled between my papa and my dad. My mom was busy trying to keep my brothers still and quiet. Mama's (my grandmother) funeral had ended, and we were all drained and a little disoriented, but Papa wanted us to see the new piano that had been donated in Mama's honor before we left the church. My dad said, "Jenna, why don't you play it?" I didn't hesitate. I was itching to play that piano. It was such a privilege to be the first to put my fingers on that keyboard in honor of Mama, who had meant so much to me. I had already played a few chords when my dad said exactly what I expected him to say. It was what he said almost every time I sat on a piano bench. "How about 'Until Then'?" So, I played the chorus. And I began to sing, as did the rest of our little family huddled around Mama's piano. It was an out-of-tune declaration of faithfulness sung from fragile hearts full of hope.

Pull up YouTube® and search for Bill and Gloria Gaither singing "Until Then."

Bill and Gloria Gaither's song was an anthem for all weary travelers and troubadours—a declaration that this troubled world was not our home.

In many ways, that is what I hear God whispering through Amos here at the very end of this amazing book of prophecy.

Oh, sister, can you believe we are on the last day of our study together? I'm so thankful for God's Word and for you. We are living the good life as we accept these God life invitations, aren't we? Let's pray as we open God's Word.

Lord, speak to us, Your children. Whatever word You speak, You will perform. We receive Your Word with open hearts and trust it is at work in us. Amen. (See Ezek. 12:25; 1 Thess. 2:13.)

OPEN YOUR BIBLE AND YOUR HEART TO AMOS 9:13-15. The book of Amos concludes with a farming image that holds hope for you. Amos started with, "Behold, days are coming" and then followed it with an explosion of horticulture!

Circle the word(s) that best represent what the horticultural images in Amos 9:13-14 suggest.

Adequacy *Scarcity* *Provision* *Abundance*

I can see a grin crease Amos's weathered face as he looked into the eyes of the Israelites and spoke those words of hope. This day of restoration was worth waiting for and looking forward to because it would be a day of blessing and abundance. The fruit was going to be so bountiful that they wouldn't be able to contain it.

Now, if you're a city girl like me, you may have needed to read those verses a couple of times to get the picture. Plowman versus reaper? Huh? Do you know the difference?

A plowman loosens soil for planting. A reaper is a person or machine that harvests a crop. So, what is happening if the plowman overtakes the reaper?

It's like these guys are tripping over each other, trying to plant and pick at the same time because the fruit grows so quickly!

Sister, when God restores you and rebuilds your life from the ruin of sin, the blessings in your life burst forth also.

Look up the references below and list your abundant blessings following the words *I have*.

EPHESIANS 1:7
I have . . .

2 PETER 1:3
I have . . .

1 JOHN 1:7
I have . . .

These blessings of restoration include forgiveness, all we need for life and godliness, and fellowship with each other. And that's just naming a few! As each blessing comes to mind, another pops up, and my heart can barely contain it all.

Such abundance and blessings belong to us, sister, and are often revealed in unexpected places.

CHECK OUT THE END OF AMOS 9:13 TO SEE WHAT I MEAN. Where did Amos suggest the grapes would be growing and the wine flowing?

I don't know much about cultivating grapevines and producing wine. In fact, I don't know one thing about it—except I usually hear about valleys when it comes to vineyards. So, I Googled it! (Who needs a brain when you have Google?) Grapes that grow in higher altitudes, like on mountains and high hills, tend to develop a thicker skin, creating more beautiful color and more complex flavor profiles. The slopes of the mountain cause rain to run off; consequently, less moisture is soaked in the soil. That means the lack of surface water forces roots to grow deeper. And it stresses the vine, causing it to use energy to develop fruit rather than just producing a leafy canopy.[16] Now, doesn't that little bit of help from Google make the end of Amos 9:13 even more stunning?

The new wine is dripping from the mountains and flowing from the hills. Behold, days are coming, sister, when blessings and abundance will spring up from the unexpected places in your life! God's blessings are rich and deeply satisfying. You read Scripture about a few of them earlier. Now take a minute to list other abundance and blessings you have received from God, especially through the book of Amos.

THE ABUNDANT LIFE IS THE GOOD LIFE.

You need to read Amos 9:14 in several translations to understand it correctly, so go online or pull out your favorite Bible resource. If you only read it in the KJV translation, you may think God was bringing Israel into captivity again. And if you read it only in the NASB translation, you may think God was going to simply fill their barns and bank accounts!

After reading several translations of this verse, what do you think Amos was saying about Israel?

A day was coming when the Israelites, God's chosen people, would again be one nation, planted on their land, and God said they would "never again be uprooted from the land I have given them" (v. 15b, CSB).

This had to be such beautiful comfort and hope for Israel. For years (and the last eight chapters of Amos), Amos had been warning the Israelites of impending captivity and exile. But now, in the final verses, like a final burst of hope, God assured His people that even though there will be bad days, there will be a day when all wrong is made right. Full restoration is on the calendar—a day when Israel would never again be pulled up from the promised land.

> Let's pause here for a few minutes to get a feel for how Israel might have received this news. You may want to brew some tea or coffee because we're about to read Psalm 37 and it has forty verses! As you read, highlight in your Bible or jot down some notes beside the references below when you read words like *inherit*, *inheritance*, and *land*.

Verse 3 _____

Verse 9 _____

Verse 11 _____

Verse 18 _____

Verse 22 _____

Verse 27 _____

Verse 29 _____

Verse 34 _____

Inheriting the land, experiencing the goodness of God in their land, and just plain living there was embedded in Israel's national soul. It was a source of hope for God's people. In this psalm, the people were really unsettled by how the wicked were seemingly prospering, so the psalmist was reassuring God's people that their inheritance was as certain as the dawn.

My friend, this is true for you too. Your inheritance in Christ is as certain as His empty tomb!

READ 1 PETER 1:3-4.

God isn't done with Israel. He will fulfill His promise made to Abraham back in Genesis 17:8.

Someday history will behold the final unfolding of God's fulfilled promise to Israel.

And God isn't finished with you or His church either. Paul said He will carry on to completion what He has started in us (Phil. 1:6). And someday, we will receive our internal inheritance in the new heaven and the new earth! Talk about the good life!

In this world, the blessings and abundance in our lives sometimes get tangled up in the weeds and thorns that grow alongside them. So, until "that day," we, like the plowman, reaper, and treader of grapes, do our thing. We live faithful and seek God. We live humble and justly as we serve others. We leverage our chosenness to bless others. We do the work of intercession, and we never stop living hopeful. There will be a harvest of righteousness someday, sister. Someday justice will roll like a river and righteousness like a mighty stream. So, until then, we seek God and live (Amos 5:4).

We live assured, chosen, and faithful. We live humble, justly, and prayerful. And we never ever, no not ever, lose hope! There will be a day, a day when we hear the heavenly music begin. We'll hear my Papa and Dad start to sing along with every nation, tongue, and tribe, and we'll join the choir as we sing of how the heartaches we experienced in this life were just stepping-stones on the path to our final glorious home.[17]

Lord, thank You for Amos. Thank You for his faithfulness to Your Word and calling. May we be found faithful to live what we have learned. We love You, oh sovereign Lord.

And all the sisters said, "Amen."

Big love to you my sister. Thanks for hanging with Amos and me until the end!

Love,

Jennifer

Day Five

YOUR GOOD LIFE DAY

Lord, I receive Your invitation to live hopeful.

Where did the message meet me this week?

What practical ways can I make Jesus my safe place to hide?

What would my life look like if I lived hopeful that there is always a "but God"?

What choices can I make to live out the abundance of my inheritance in Christ?

This week, God taught me . . .

MY GOOD LIFE DECLARATION

To live the good life, I will live the God life and . . .

I will let go of:

I will trust God with:

I will take hold of:

To make your Good Life Day even better, listen to my #GoodLife playlist at jenniferrothschild.com/amos.

INVITATION SEVEN:
Live Hopeful

BEFORE THE VIDEO
Welcome and Prayer

VIDEO NOTES

To access the video teaching sessions, use the instructions in the back of your Bible study book.

If _____ is the narrator, this story is going to end OK.

THREE PLOT TWISTS OF HOPE:

1. Hope _____ fallen things.

 John 1:14 says the Word became flesh and _____ among us.

 If your God is _____, then so is your hope. But if your God is

 not _____, then never will your hope be dead, and your God is

 not _____.

2. Hope _____ broken things.

3. Hope _____ all things.

 Earth is _____, and heaven is _____.

Don't forget to go to jenniferrothschild.com/amos to get a written summary of the video message sent to your inbox.

CONVERSATION GUIDE

DAY ONE: What are some things outside of Christ that people in the world put their hope in? Do you ever find yourself shifting your hope to some of those things? Explain. What does it mean that we are hidden in Christ? How would you explain that to a new believer? And why is there such hope in that truth?

DAY TWO: How does knowing God is sovereign give us hope? Are you currently facing a situation that just knowing God is sovereign brings you comfort and helps you keep looking forward? Explain. How are *nevertheless* and *but God* words of hope? What's a *nevertheless* or *but God* moment in your life when the Lord stepped into your mess and turned it around?

DAY THREE: Do you look forward to the "day of the LORD," or do you dread it? Explain. Why does knowing this future "day" is coming give you hope? Our God is a God of restoration. What are some things you're looking forward to God restoring?

DAY FOUR: What are some blessings of restoration you have seen in your life and the lives of those around you? What hope and comfort do you find in knowing that God is not finished with you yet and that He is carrying on to completion what He started in you?

VIDEO: How has hope repaired things in your life? One day God will renew all things. What are you most looking forward to in that day? What is something God taught you this week? Why is it so important that you accept God's invitation to live hopeful?

BIBLE STUDY RESOURCES

There are so many resources available to help us dig deeper into God's Word. It's wonderful, but it can be overwhelming. Where to start? Who to trust? Here are a few tried and true go-to resources you can use during this study.

ONLINE TOOLS

- biblehub.com
- biblegateway.com
- biblestudytools.com
- blueletterbible.org
- The Bible app (YouVersion)
- Dwell Audio Bible app (Visit jenniferrothschild.com/dwell to see me use it and hear why it's one of my favorites.)

PRINT RESOURCES

- *The New Strong's Expanded Exhaustive Concordance of the Bible* by James Strong
- *Matthew Henry's Concise Commentary on the Whole Bible*
- *Holman Bible Commentaries*
- *The New American Commentaries*
- *The Zondervan Encyclopedia of the Bible* by Merrill C. Tenney and Moisés Silva

The good life gets even better when you share it with friends! There are three bonus episodes featuring conversations with Kelly Minter, Nicole C. Mullen, and Stormie Omartian. I feature them in sidebars in "Invitation Two: Live Faithful" on page 57, "Invitation Four: Live Humble" on page 112, and in "Invitation Six: Live Prayerful" on page 151. These fun and practical conversations will make the principles in Amos even more inviting and assessable. Encourage the women you lead to watch the videos during that week of study or watch them together as a group whenever you choose. These are bonus videos streaming on the Lifeway On Demand app with your teaching videos.

LEADER HELPS

Thanks so much for leading your group through this study! I know you'll experience joy and lots of blessings as you walk your group through the study of Amos. I'm praying for you as you take on this responsibility.

I've put together a little something for you, sweet sister. Use the QR code to go to jenniferrothschild.com/amos to get it. You'll find some of the most creative ways leaders are making this study fun and meaningful. And you can share your ideas there, too. You can also find leader resources at lifeway.com/amos.

POINT CAMERA

STUDY FORMAT

GROUP SESSIONS: Each group session contains the following elements: Welcome and Prayer / Watch the Video / Group Discussion. You can access the video content from the card in the back of your Bible study book. The group discussion provides questions generated from the previous invitation's personal study and the video teaching. Feel free to adapt, skip, or add questions according to the needs of your group.

PERSONAL STUDY: Each invitation contains four days of personal study and finishes with a "good life" day to help women live what they have learned.

BEING AN EFFECTIVE LEADER

Three keys to being an effective leader of your group:

1. **PREPARE.** Make sure you've watched the teaching video and completed each invitation's personal study before the group session. Review the discussion questions and consider how best to lead your group through this time.

2. **PRAY.** Set aside time each week to pray for yourself and each member of your group. Though organizing and planning are important, protect your time of prayer before each gathering.

3. **CONNECT.** Find ways to interact and stay engaged with the women in your group throughout the study. Make use of social media, emails, and handwritten notes to encourage them. And don't stop the connection when the study ends. Continue to encourage and challenge the women in your group in their spiritual journey.

Notes

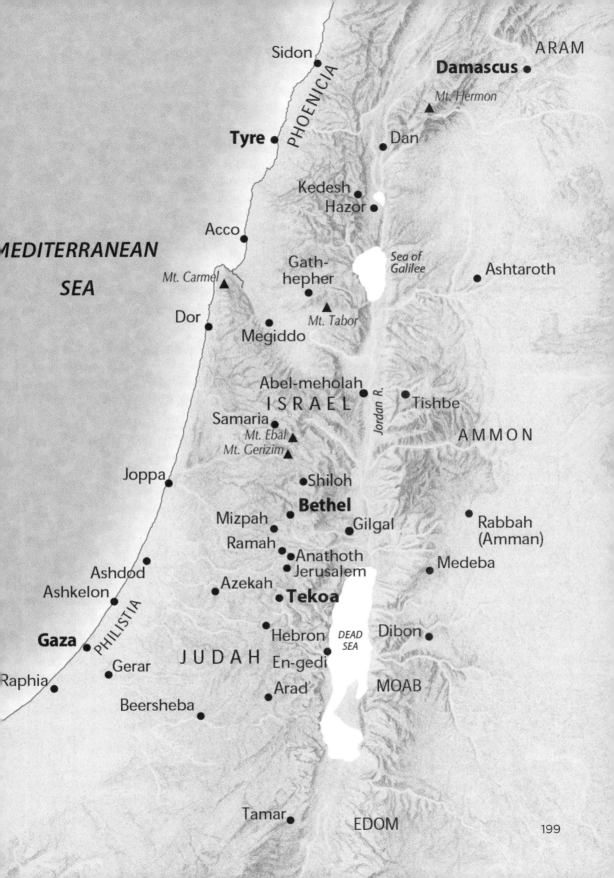

Sidon

ARAM

Damascus

Mt. Hermon

PHOENICIA

Tyre

Dan

Kedesh

Hazor

Sea of Galilee

Acco

Ashtaroth

MEDITERRANEAN

SEA

Mt. Carmel

Gath-
hepher

Dor

Mt. Tabor

Megiddo

Abel-meholah

Jordan R.

Tishbe

ISRAEL

Samaria

AMMON

Mt. Ebal

Mt. Gerizim

Joppa

Shiloh

Bethel

Mizpah

Gilgal

Rabbah
(Amman)

Ramah

Anathoth

Ashdod

Jerusalem

Medeba

Ashkelon

Azekah

Tekoa

Gaza

PHILISTIA

Hebron

DEAD
SEA

Dibon

JUDAH

En-gedi

Gerar

MOAB

Raphia

Arad

Beersheba

Tamar

EDOM

Endnotes

INVITATION ONE

1. Bishop Lowth, as quoted by Adam Clarke, *The Holy Bible with a Commentary and Critical Notes*, New Edition, vol. 4 (Bellingham, WA: Faithlife Corporation, 2014), 672.

2. The Editors of *Encyclopedia Britannica*, "Amos," *Encyclopedia Britannica*, February 26, 2021, https://www.britannica.com/topic/biblical-literature/Amos#ref597780.

3. Strong's H54349, Blue Letter Bible, https://www.blueletterbible.org/lexicon/h5349/kjv/wlc/0-1/.

4. Steve Law, "Biblical Quake Confirmed, Prophesied by Amos," Patterns of Evidence, January 20, 2019, https://patternsofevidence.com/2019/01/20/biblical-quake-confirmed/.

5. Ibid.

6. "Amos 1—Judgment on the Nations," Enduring Word Commentary, https://enduringword.com/bible-commentary/amos-1/.

7. Alfred Lord Tennyson, Queen Mary (London: Henry S. King & Co., 1875), 251.

8. "Why does Amos keep repeating "for three sins . . . even for four" in chapters 1–2?" Got Questions, https://www.gotquestions.org/three-sins-even-for-four.html.

9. Strong's H6588, Blue Letter Bible, https://www.blueletterbible.org/lexicon/h6588/kjv/wlc/0-1/.

10. Billy K. Smith and Franklin S. Page, *Amos, Obadiah, Jonah*, vol. 19B, The New American Commentary (Nashville: Broadman & Holman Publishers, 1995), 47.

11. David A. Hubbard, *Joel and Amos: An Introduction and Commentary*, vol. 25, Tyndale Old Testament Commentaries (Downers Grove, IL: InterVarsity Press, 1989), 137.

12. James Montgomery Boice, *The Minor Prophets: An Expositional Commentary* (Grand Rapids, MI: Baker Books, 2002), 172.

13. Smith and Page, *Amos, Obadiah, Jonah*, 53.

14. David Guzik, "ZECHARIAH 2 – A CITY WITHOUT WALLS," Enduring Word, 2018, https://enduringword.com/bible-commentary/zechariah-2/.

15. Elyssa Smith, performed by Michael W. Smith, "Surrounded (Fight My Battles)," ©2017 Rocketown Records/The Fuel Music.

16. "Who/what is Edom (Obadiah 1:1,8)?" GotQuestions, https://www.gotquestions.org/Edom-Obadiah.html

17. Stormie Omartian, *Seven Prayers that will change your life forever* (Nashville: Thomas Nelson, 2006), 47.

18. Shaunti Feldhahn, *The Kindness Challenge* (New York: WaterBrook, 2016), 14.

INVITATION TWO

1. John Stott, *The Westminster Collection of Chrisian Quotations* (Louisville: Westminster John Knox Press, 2001), 19.

2. J. C. Watts, as quoted by Don Soderquist, *Live Learn Lead to Make a Difference* (Nashville: J.Countryman, 2005).

3. Smith and Page, *Amos, Obadiah, Jonah*, 62.

4. Strong's H7602, Blue Letter Bible, https://www.blueletterbible.org/lexicon/h7602/kjv/wlc/0-1/.

5. Adam Clarke, *The Holy Bible with a Commentary and Critical Notes*, New Edition, vol. 4 (Bellingham, WA: Faithlife Corporation, 2014), 677.

6. Strong's H4616, Blue Letter Bible, https://www.blueletterbible.org/lexicon/h4616/kjv/wlc/0-1/.

7. Esther Fleece Allen, "How to Make it Through the Holidays When You Don't Feel Very Grateful," Faithgateway, November 23, 2020, https://www.faithgateway.com/how-to-be-grateful-holidays/#.Ymm4tPPMKYA.

8. Smith and Page, 68.

9. Matthew Henry, "Note on Amos 2:13," *Zondervan NIV Matthew Henry Commentary* (Grand Rapids, MI: Zondervan, 2010).

10. Albert Barnes, "Note on Amos 2:13," *Barnes' Notes on the Whole Bible*, https://www.studylight.org/commentaries/eng/bnb/amos-2.html.

11. Ibid.

12. David Guzik, "AMOS 2 – JUDGMENT ON GOD'S PEOPLE," Enduring Word Commentary, https://enduringword.com/bible-commentary/amos-2/.

13. Friedrich Nietzsche, *Beyond Good and Evil*, 1886, trans. Helen Zimmern, December 7, 2009, Gutenberg.org, https://www.gutenberg.org/files/4363/4363-h/4363-h.htm

14. Ibid.

INVITATION THREE

1. Tim Keller, *The Meaning of Marriage* (New York: Penguin Books, 2011).

2. Strong's H3045, Blue Letter Bible, https://www.blueletterbible.org/lexicon/h3045/kjv/wlc/0-1/.

Strong's G1097, Blue Letter Bible, https://www.blueletterbible.org/lexicon/g1097/kjv/tr/0-4/#lexResults.

Seneca the Younger, *Seneca's Letters from a Stoic*, trans. Richard Mott Gummere (Mineola, New York: Dover Publications, Inc. 2016), 89.

"The Science of Stories: How Stories Impact Our Brain," Quantified, April 2, 2018, https://www.quantified.ai/blog/the-science-of-stories-how-stories-impact-our-brains/.

Norman Doidge, M.D., *The Brain That Changes Itself* (New York: Penguin Books, 2007), 63.

C. S. Lewis, Reflections on the Psalms (London: Harcourt Books, 1958), 5.

Jim Elliot, as quoted by Elisabeth Elliot, *Shadow of the Almighty* (Peabody, MA: Hendrickson Publishers, 1989), 11.

Gary V. Smith, *Hosea, Amos, Micah*, The NIV Application Commentary (Grand Rapids, MI: Zondervan Publishing House, 2001), 370.

INVITATION FOUR

. Rick Warren, *The Purpose Driven Life: What on Earth Am I Here For?* (Zondervan, 2002), 148.

. Ray Vander Laan, "Assyrian Conquests," That the World May Know, https://www.thattheworldmayknow.com/assyrian-conquests.

. Karen Radner, "Israel, the 'House of Omri,'" Assyrian empire builders, University College London, 2012, https://www.ucl.ac.uk/sargon/essentials/countries/israel#:~:text=722%20BC%3A%20the%20taking%20of,conquered%20the%20city%20of%20Samaria.

. C. S. Lewis, *The Essential C. S. Lewis*, ed. Lyle W. Dorsett (New York: Scribner, 1996), 319.

5. Kerry Lee, "The Cows of Bashan — Amos 4:1-3," Bite-Sized Exegesis, February 6, 2017, https://bitesizedexegesis.com/2017/02/06/the-cows-of-bashan-amos-41-3/.

. Smith and Page, 85.

. G. Smith, *Amos, Mentor Commentaries*, 177.

. Henry Wadsworth Longfellow, *Hyperion*, 1882, https://www.gutenberg.org/files/5436/5436-h/5436-h.htm.

. Lecrae, "The world's smallest package ..." Tweet, July 14, 2014, https://twitter.com/lecrae/status/488654532935974914.

10. Trent C. Butler, *Hosea, Joel, Amos, Obadiah, Jonah, Micah*, ed. Max Anders, vol. 19, Holman Old Testament Commentary (Nashville, TN: Holman Reference, 2005), 93.

11. David Guzik, "AMOS 4 – "YET YOU HAVE NOT RETURNED TO ME," Enduring Word, 2018, https://enduringword.com/bible-commentary/amos-4/.

12. Strong's H157, Blue Letter Bible, https://www.blueletterbible.org/lexicon/h157/kjv/wlc/0-4/#lexResults.

13. Heinrich Friedrich Wilhelm Gesenius, *Gesenius' Hebrew-Chaldee Lexicon*, Blue Letter Bible, https://www.blueletterbible.org/lexicon/h157/kjv/wlc/0-1/#lexResults.

14. Commonly attributed to Saint Augustine, as quoted by Jonathan L. Kvanvig, *Faith and Humility* (Oxford: Oxford University Press, 2018), 178.

15. Abram Loft, *Violin and Keyboard*, vol. I (Portland: Amadeus Press, 1973), 209.

16. David Guzik, "AMOS 3 – THE LOGIC OF GOD'S JUDGMENT," Enduring Word Commentary, 2018, https://enduringword.com/bible-commentary/amos-3/.

17. Smith and Page, 82.

18. Rick Warren, *The Purpose Driven Life: What on Earth Am I Here For?* (Zondervan, 2002), 148.

INVITATION FIVE

1. Esther Fleece Allen, *No More Faking Fine* (Grand Rapids, MI: Zondervan, 2016).

2. Smith and Page, 97.

3. David Guzik, "AMOS 5 – THE OFFERINGS GOD HATES," Enduring Word, https://enduringword.com/bible-commentary/amos-5/.

4. Strong's H1875, Blue Letter Bible, https://www.blueletterbible.org/lexicon/h1875/kjv/wlc/0-1/.

5. Strong's H4097, Blue Letter Bible, https://www.blueletterbible.org/lexicon/h4097/kjv/wlc/0-1/.

6. Smith and Page, 97.

7. Strong's G3341, Blue Letter Bible, https://www.blueletterbible.org/lexicon/g3341/kjv/tr/0-1/.

8. Matthew Henry, *The Matthew Henry Study Bible* (Dordrecht: Importantia Publishing, 2010), 554.

9. Thomas Ken, "Praise God From Whom All Blessings Flow, 1774, accessed via Hymnary.org, https://hymnary.org/text/praise_god_from_whom_all_blessings_ken.

10. Plutarch, as quoted by James S. Bowman and Jonathan P. West, *Public Service Ethics* (New York and London: Routledge, Taylor & Francis Group, 2021).

11. Smith and Page, 102.

12. Strong's H2896, Blue Letter Bible, https://www.blueletterbible.org/lexicon/h2896/kjv/wlc/0-1/.

13. Strong's H7451, Blue Letter Bible, https://www.blueletterbible.org/lexicon/h7451/kjv/wlc/0-1/.

14. Martin Luther King, Jr., "Introduction to Southwest Africa: The U.N.'s Stepchild," ACOA, October, 1959.

15. Martin Luther King, Jr., "Letter From Birmingham Jail," April 16, 1963, https://www.africa.upenn.edu/Articles_Gen/Letter_Birmingham.html.

16. Billy Graham, *The Holy Spirit: Activating God's Power in Your Life* (Grand Rapids, MI: Zondervan, 1978), 224.

17. Boice, *The Minor Prophets: An Expositional Commentary*, 218.

18. Hubbard, *Joel and Amos: An Introduction and Commentary*, 232.

INVITATION SIX

1. Charles H. Brent, *In Joy and Strength*, ed. Mary Wilder Tileston (Boston: Little, Brown, and Company, 1901), 351.

2. Dictionary.com, s.v. "sovereign," https://www.dictionary.com/browse/sovereign.

3. David Guzik, "AMOS 7 – VISIONS OF JUDGMENT AND THE POWER OF THE PROPHET'S PRAYER," Enduring Word, https://enduringword.com/bible-commentary/amos-7/.

4. Smith and Page, 128.

5. Cunningham Geikie, *Hours with the Bible* (Astor Place, New York: James Pott & Co., Publishers, 1891), 149.

6. Hubbard, 219–220.

7. Smith and Page, 131.

8. Hubbard, 219–220.

9. E. M. Bounds, *The Complete Works of E. M. Bounds* (Summit, NJ: Start Publishing, 2012).

10. Strong's H5162, Blue Letter Bible, https://www.blueletterbible.org/lexicon/h5162/kjv/wlc/0-1/.

11. John Piper, "God Is Most Glorified in Us When We Are Most Satisfied in Him," Desiring God, October 13, 2022. https://www.desiringgod.org/messages/god-is-most-glorified-in-us-when-we-are-most-satisfied-in-him.

12. Francis Chan, *Forgotten God* (Colorado Springs: David C. Cook, 2009), 182.

13. Malcolm Muggeridge, *Christ and the Media* (Vancouver: Regent College Publishing, 1977), 25.

14. James Montgomery Boice, *Psalms 42–106: An Expositional Commentary* (Grand Rapids, MI: Baker Books, 2005), 660.

15. Strong's H6225, Bible Hub, https://biblehub.com/hebrew/6225.htm.

16. Charles Ellicott, "Note on Psalm 80:4," *A New Testament Commentary for English Readers* (London: Cassell and Co., 1897).

INVITATION SEVEN

1. John Newton, "Four Letters," April 15, 1776, *The Works of the Rev. John Newton*, vol. 1 (London: Nathan Whiting, 1824), 39.

2. Edward Mote, "My Hope Is Built on Nothing Less," 1834, https://hymnary.org/text/my_hope_is_built_on_nothing_less.

3. Albert Mohler, "The End of History—The Moral Necessity of Eschatology," The Southern Baptist Theological Seminary, June 9, 2008, https://albertmohler.com/2008/06/09/the-end-of-history-the-moral-necessity-of-eschatology.

4. Thomas Ken, "Praise God From Whom All Blessings Flow," 1674, https://hymnary.org/text/praise_god_from_whom_all_blessings_ken.

5. David Guzik, "AMOS 9 – RAISING UP THE RUINS," Enduring Word, https://enduringword.com/bible-commentary/amos-9/.

6. Hubbard, 246.

7. Smith and Page, 162.

8. Flannery O'Connor, *Letters of the Habit of Being* (New York: Farrar, Straus and Giroux, 1979), 100.

9. John Hill Aughey, *Spiritual Gems of the Ages* (Cincinnati: Elm Street Printing Company, 1886), 444.

10. Gary V. Smith, Isaiah 1–39, ed. E. Ray Clendenen, *The New American Commentary* (Nashville: B & H Publishing Group, 2007), 300.

11. Ibid.

12. "What is the day of the Lord?" GotQuestions, https://www.gotquestions.org/day-of-the-Lord.html.

13. Guzik, "Amos 9 . . ." https://enduringword.com/bible-commentary/amos-9/.

14. John Piper, "Rebuilt Ruins Will Reach the World," Desiring God, June 28, 1987, https://www.desiringgod.org/messages/rebuilt-ruins-will-reach-the-world.

15. C. H. Spurgeon, "A Sermon (No. 296)," delivered January 26, 1860, at Exeter Hall, Strand, https://www.blueletterbible.org/Comm/spurgeon_charles/sermons/0296.cfm.

16. "How Does Altitude Affect Wine?" Stonestreet Estate Vineyards, https://www.stonestreetwines.com/how-does-altitude-affect-wine#:~:text=High%20elevation%20mountain%20and%20hillside,color%20concentration%20and%20stronger%20tannins..

17. Stuart Hamblen, "Until Then," © 1958 Hamblen Music. https://hymnary.org/text/my_heart_can_sing_when_i_pause_to_rememb.

Notes

LET'S BE FRIENDS!

BLOG

We're here to help you grow in your faith, develop as a leader, and find encouragement as you go.

lifewaywomen.com

SOCIAL

Find inspiration in the in-between moments of life.

@lifewaywomen

NEWSLETTER

Be the first to hear about new studies, events, giveaways, and more by signing up.

lifeway.com/womensnews

APP

Download the Lifeway Women app for Bible study plans, online study groups, a prayer wall, and more!

 Google Play App Store

Lifeway women

TAKE COURAGE
7 Sessions

Study the minor prophet of Haggai to learn to see beyond your current circumstances to a future in Christ.

lifeway.com/takecourage

PSALM 23
7 Sessions

Explore the depths of God's compassionate care while gaining fresh insight and encouragement from Psalm 23.

lifeway.com/psalm23

HOSEA
7 Sessions

Dive into the passionate love story of Hosea to identify the modern-day idols in your life and step into the freedom of Christ.

lifeway.com/hosea

MISSING PIECES
7 Sessions

Explore the messy and mysterious uncertainties of faith to learn to trust Jesus over emotion.

lifeway.com/missingpieces

ME, MYSELF & LIES
7 Sessions

Examine your thoughts and words to identify the negativity in your daily inner dialogue and replace negative thoughts with positive truths from God's Word.

lifeway.com/memyselfandlies

PERSONALIZE *the* MESSAGE *of* AMOS

with this DECLARATION CARD *and*
THE GOOD LIFE NECKLACE

• • •

see details and order information
JenniferRothschild.com/Amos

POINT CAMERA

Get the most from your study.

IN THIS STUDY, YOU'LL:

- Uncover the connection between the God life and the good life.
- Learn how God's care for us prompts us to care for others.
- Break hope-stealing habits to reverse self-defeating choices.
- Unearth the gems hidden within one of the most overlooked books in the Bible.

To enrich your study experience, consider the accompanying *Amos* video teaching sessions, approximately 30 minutes, from Jennifer Rothschild.

STUDYING ON YOUR OWN?

Watch Jennifer Rothschild's teaching sessions, available via redemption code for individual video-streaming access, printed in this Bible study book.

LEADING A GROUP?

Each group member will need an *Amos* Bible Study Book, which includes video access. Because all participants will have access to the video content, you can choose to watch the videos outside of your group meeting if desired. Or, if you're watching together and someone misses a group meeting, she'll have the flexibility to catch up! A DVD set is also available to purchase separately if desired.

Browse study formats, a free study sample, video clips, church promotional materials, and more at

lifeway.com/amos